MADE IN JAPAN

Transistor Radios

OF THE

1950s AND 1960s

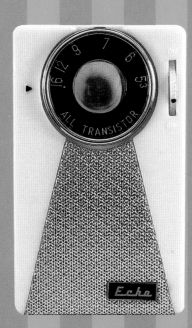

ROGER HANDY, MAUREEN ERBE, AILEEN ANTONIER

PHOTOGRAPHY BY HENRY BLACKHAM

CHRONICLE BOOKS

SAN FRANCISCO

7

6

54

KC

TRANSISTOR

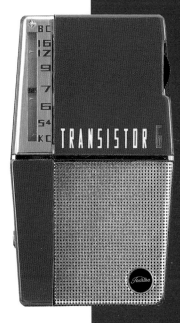

It's not much bigger than a pack of cigarettes. After initial high prices, it was relatively inexpensive. It ran on a nine-volt battery and didn't always provide the best reception. So why is such a seemingly humble item as the shirt-pocket transistor radio deserving of such attention?

R A D I O R E A D Y M A D

Just think about it. It let you swoon to Elvis or rant to the Rolling Stones in the privacy of your room, far removed in spirit from the living room, where your hopelessly square parents listened to their old-fogey music. Discreet use of the earphone brought you the play-by-play de-scription of a thrilling World Series game while you were tethered to your school or work desk. You even used the radio at the ballgames for color commentary – as one writer noted in the shirt-pocket radio's early days, "Just picture yourself at the ballgame if you draw a seat out in left field, getting the blow-by-blow out of your hankie pocket." It created a portable romantic ambiance, accompanying you in the sand dunes with your first summer love, where you made some startling (but altogether pleasant) discoveries. And it wasn't just you.

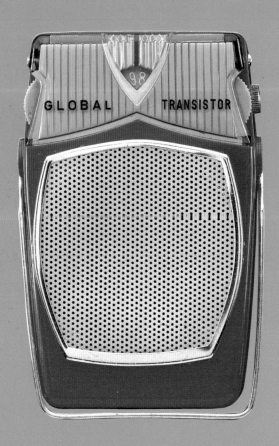

The transistor radio was destined to become one of the first distinctive emblems of the emerging post-war youth culture, integral as it was to the issues of defiance, sex, freedom, music, and mobility as they evolved throughout the fifties and sixties.

Maybe it's just a coincidence that American society radically changed in the wake of the transistor radio.

But maybe not.

The transistor radio also represented a startling technological leap, without which such commonplace things as personal computers, satellites, and pocket calculators would not exist today. And it helped catapult Japan to the preeminent position in consumer electronics design and manufacturing that it holds today.

More than an icon for popular culture, a point of no return for American values, a seminal piece of technical wizardry, and the first volley in the continuing skirmish of goods production between Japan and America, the transistor radio is an art form in its own right. The celebrated artist

Marcel Duchamp coined the term "ready-mades" to describe a series of unaltered, everyday objects he exhibited "as-is" as art. He asserted that his selection of an object for purposes of display was sufficient condition to elevate that object to the status of art. We suspect today Duchamp would have found the transistor radio a most compelling candidate for such display in a gallery.

In that spirit, the emphasis in this book will be on the aesthetic glories of the transistor radio and on some of the more compelling aspects of the genre as a reflection of contemporary popular culture. Although "made in Japan," the transistor radio smacks of things most American: baseball, our love affair with the automobile, and rock 'n' roll. It takes us back to the days of optimism, opportunity, and patriotism.

Dismissed as passé by a fickle public in search of ever-new sensations, the transistor radio has recently been rescued by collectors and curators from the obscurity in which it has unjustly languished. We think it deserves a new look. After you peruse *Made in Japan*, we hope you'll agree.

9

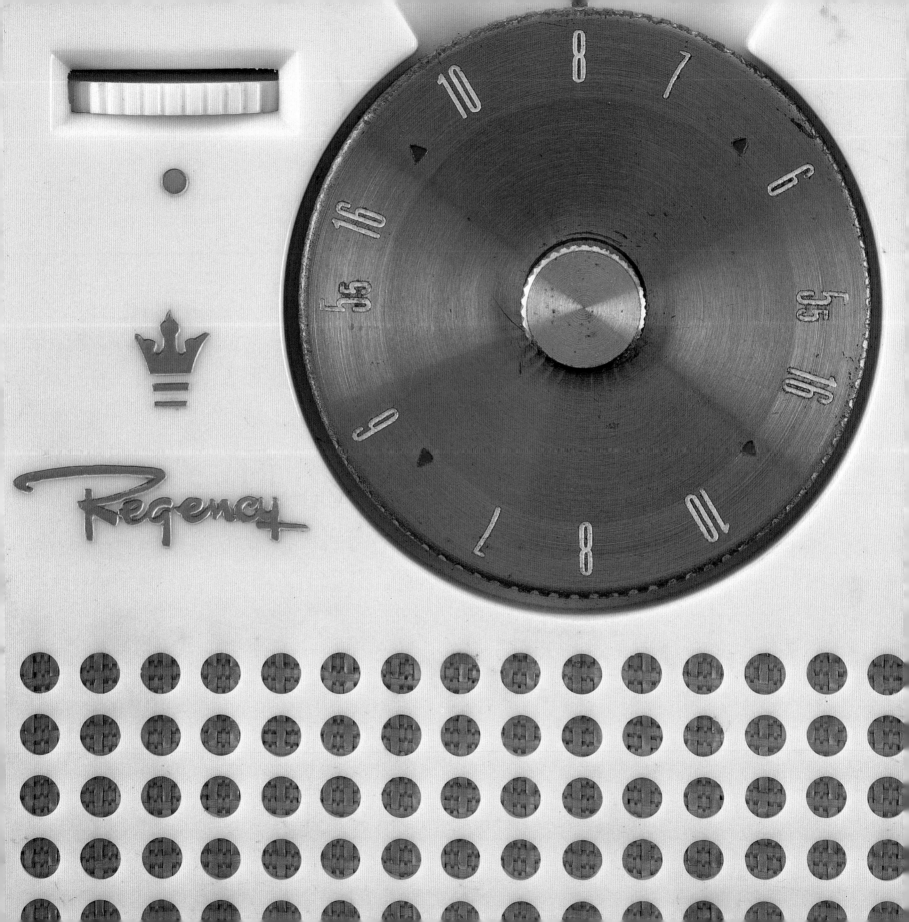

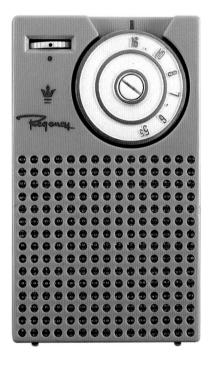

American Antecedents

We inhabit a world in which laptop computers and portable cellular phones are commonplace. We have Walkmans to accompany our every

pursuit. Televisions plug into our cars' cigarette lighters. We tote personal photocopiers. It seems as if there is no end to advances in consumer

electronics. But it has been only forty years since any of these things we now take for granted was remotely possible. How did we come so

far so fast? That question can be answered to a remarkable extent by an examination of the evolution of the shirt-pocket transistor radio

12

In 1948, Bell Laboratories announced that the scientific team of William Shockley, Walter Brattain, and John Bardeen had invented a solid-state amplifier, which they named the "transistor." This device was a noteworthy improvement upon the vacuum tube as a means of regulating the flow of electric current because it was smaller, more durable, and consumed less power. The way had been paved for the advent of the transistor during World War II, when the "semiconducting" qualities of the elements silicon and germanium were first explored. The trio was awarded the Nobel Prize in Physics for their work, and semiconductors have been the basic components of electronics ever since.

In July 1954, engineers from Houston-based Texas Instruments met with their counterparts from the Indianapolis electronics firm IDEA (Industrial Development Engineering Associates) to kick off a secret project, one that would be the first step in a grand strategy to transform TI from a business of modest size and stature into a major industrial enterprise. The plan sounds deceptively modest today – to have the world's first shirt-pocket all-transistor radio in the stores by Christmas. For the engineers and designers involved, it was the challenge of a career.

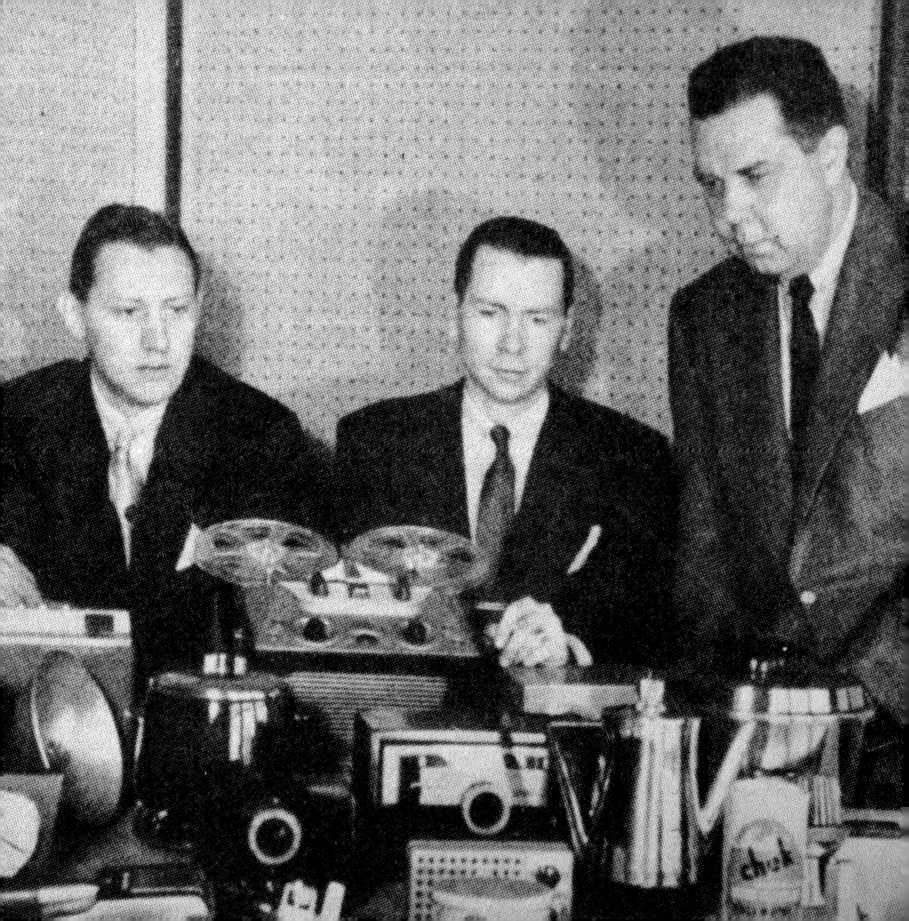

The design program for the radio was undertaken by the esteemed industrial design firm of Painter, Teague and Petertil. One of their promotional brochures proudly proclaimed that Painter, Teague and Petertil had designed everything from "toothbrushes to earthmovers," and their list of clients included some of the biggest names in modern industry. They had never faced an assignment quite like that delegated to them by IDEA, however.

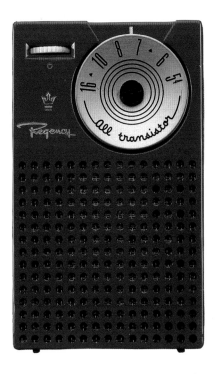

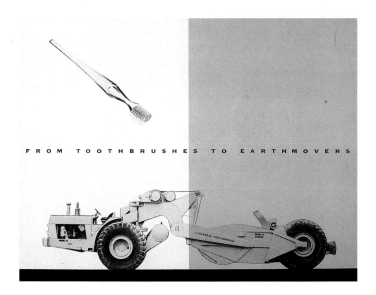

FROM TOOTHBRUSHES TO EARTHMOVERS

The design team labored heroically under a merciless deadline and unforgiving specifications, working with tolerances of plus or minus five-thousandths of an inch. As Jim Teague succinctly noted about the challenge, "The speaker and battery really hogged the whole thing." Recalled as a "super crash program" by Dave Painter, the feat was accomplished mostly by way of marathon telephone conversations and design sketches hurriedly exchanged through the mails over a period of roughly six weeks.

The distinctive grille on the radio's cabinet, which came to

exemplify modernity and space-age styling, actually started

out as a bit of serendipity for the designers. Drilling a regular

grid of small holes in the speaker area was simply the quick-

est, easiest, and least expensive way of fashioning the cor-

responding templates and dies. Thus a classic look was born.

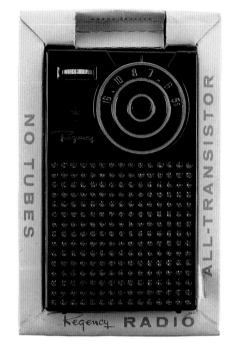

The radio was dubbed the Regency TR-1. Upon its introduction, a *Consumer Reports* article dourly stated, "... the Regency has made use of the transistor's small size, but the set offers no other advantages ... The consumer who has been waiting for transistor radios to appear would do well to await further developments before buying." Apparently pent-up curiosity was greater than the restraint recommended in this cool assessment. The Regency TR-1 was a success – approximately a hundred thousand were sold during the first year, and black markets appeared in cities in which the radios were not available.

The radio garnered admiration for its design as well, winning an award from the Industrial Design Society of New York and being selected by the Museum of Modern Art for the American Art and Design Exhibition in Paris in 1955.

A marvel of the latest electrical engineering at the time of its creation, the TR-1 synthesized the trend toward miniaturization, the use of new materials, versatility and disposability, and the principles of planned obsolescence that have come to characterize so many of the electronic goods – and for that matter, almost all other commercial merchandise – available to today's consumer. The TR-1, however, did not win over the American mass market. That broad acceptance was reserved for its cousins from Japan.

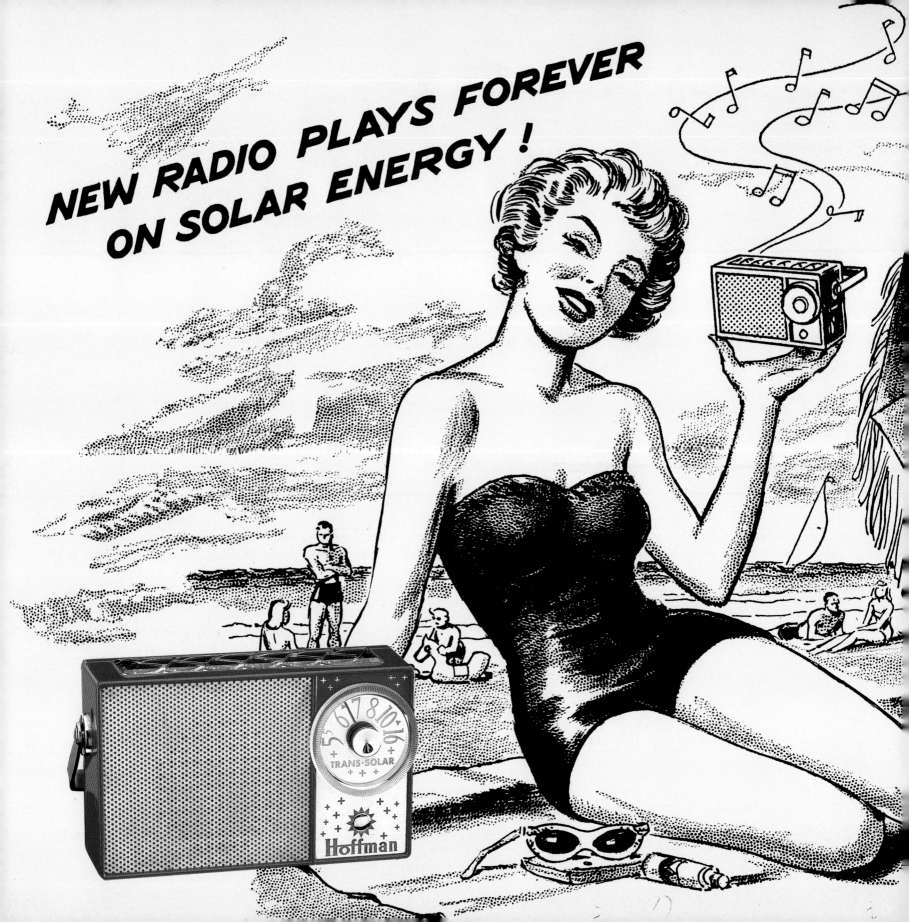

TINY CELLS IN THE TOP ACTUALLY TURN SUNLIGHT INTO ELECTRICITY - KEEP THIS PORTABLE PLAYING INDEFINITELY. (AT NIGHT IT USES BATTERIES.) BUT THE HEAT OF THE SUNLIGHT THAT RUNS THIS RADIO IS DESTRUCTIVE TO MOST PLASTICS. SO, FOR THE CASE, THE MAKERS CHOSE **B-W MARBON CHEMICAL'S** <u>CYCOLAC*</u> <u>PLASTIC.</u> IT WITHSTANDS THE ELEMENTS, RESISTS WARPING AND DISCOLORATION. AND IT WON'T CRACK OR BREAK, EVEN IF DROPPED.

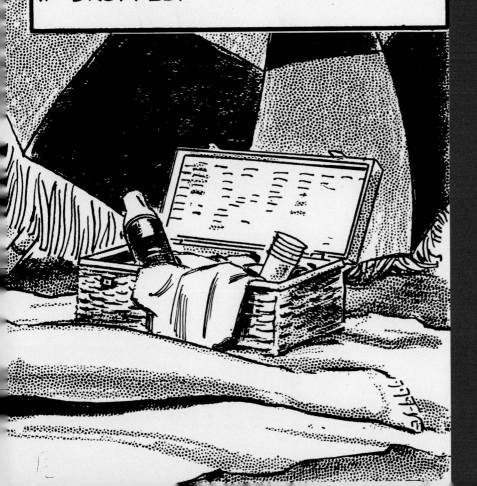

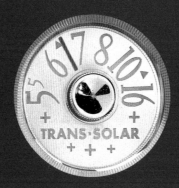

This solar-powered Hoffman "Trans-Solar" radio is just one example of Yankee ingenuity ahead of its time. The color TV, VCR, and desktop computer are other American innovations envisioned and developed decades before their eventual acceptance in the marketplace. Michael Brian Schiffer, author of *The Portable Radio in American Life*, believes neglect of these facts has weakened collective American pride and faith in its capabilities. He puts forth his theory of "cryptohistory," that is, that product history promulgated by multinational corporations to serve their own needs (i.e., that the Japanese invented the first pocket-sized, all-transistor radio) is often at odds with the truth and downplays American inventiveness. He writes, "Such beliefs deny the rich heritage of American invention (that thrives to this day) in tinkerers' workshops, universities, governments, laboratories, and corporations - large and small.... To surrender the past then is to surrender the future."

Early American radios took their cues from the design of the award-winning Regency TR-1. Clean in line, Spartan in detail, the radios reflected the "International Style" of design, which was then quite popular. When the Japanese later entered the market, their radios reflected the same general design influences as those of American radios, but with a distinctly different spin.

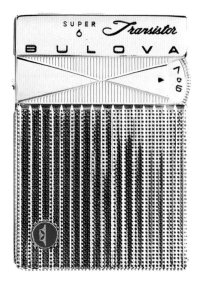

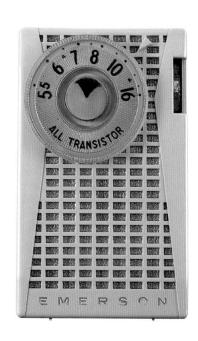

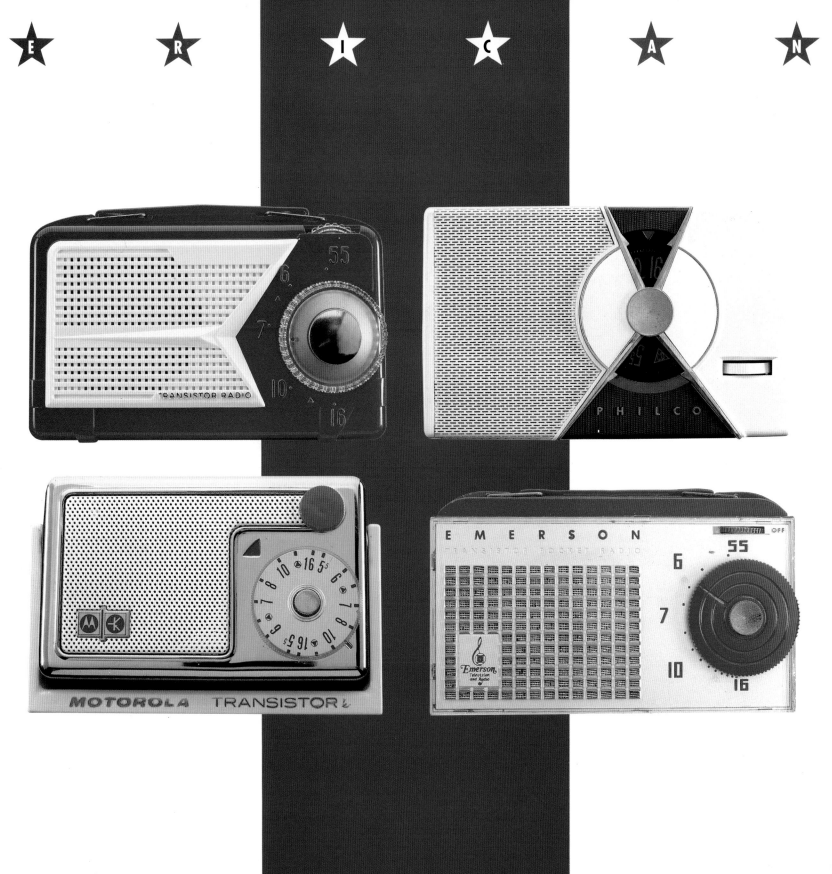

THE JAPANESE INCURSION

I'll Trade Ya

Around the time that the TR-1 hit the market, a young company in Japan called Tokyo Telecommunications Engineering Co., Ltd. was developing its own version. In keeping with the philosophy of a better tomorrow through progressive technology, Masuru Ibuka, an electrical engineer, and Akio Morita, a physicist, had founded the company shortly after World War II. Their aim was to combine the fields of electrical and mechanical engineering to produce unique consumer electronic goods. Housed on the third floor of a war-gutted department store, the fledgling company consisted of seven employees, a few sticks of furniture, a meager assortment of engineering equipment, and operating capital equivalent to about five hundred dollars. But Tokyo Telecommunications had a major asset: two principals with a vision of the future and enough optimism and ambition to make it a reality.

within two years, new enterprise would employ almost five hundred workers and successfully market Japan's first commercial tape recorder. They were strengthening and expanding, but still they had no product with which they felt they could really make their mark. Ibuka visited the United States in 1952 to formulate uses for the company's tape recorders and to get a feel for the latest developments in science and technology. When he learned that licenses to the transistor patent were to be released, he knew he had found the project that would challenge the already impressive talents of his engineers – a transistorized radio that would be small and compact enough to fit inside a shirt pocket.

Tokyo Telecommunications paid out the $25,000 advance for the rights to transistor technology and in 1955 released its first transistor radio, a coat-pocket model, called the TR-55. It bore the brand name "Sony," a nomenclature rather enigmatically described in sixties-era corporate literature as "an Anglicized version of the Latin word 'soni' (the plural of 'sonus' meaning sound) and 'sonny' (English)." The TR-55 was not marketed in America; a shirt-pocket model introduced two years later, the TR-63, was. The company name itself was subsequently changed to Sony.

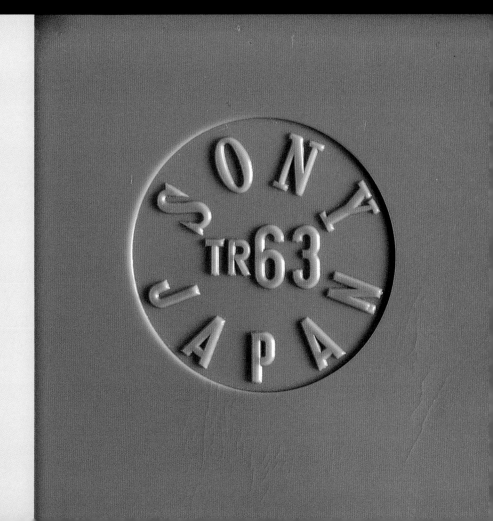

The TR-63 was slightly larger than Japanese shirt pockets, so Sony issued shirts with larger pockets to its salesmen, who could then demonstrate the virtues of "pocketability" to interested customers.

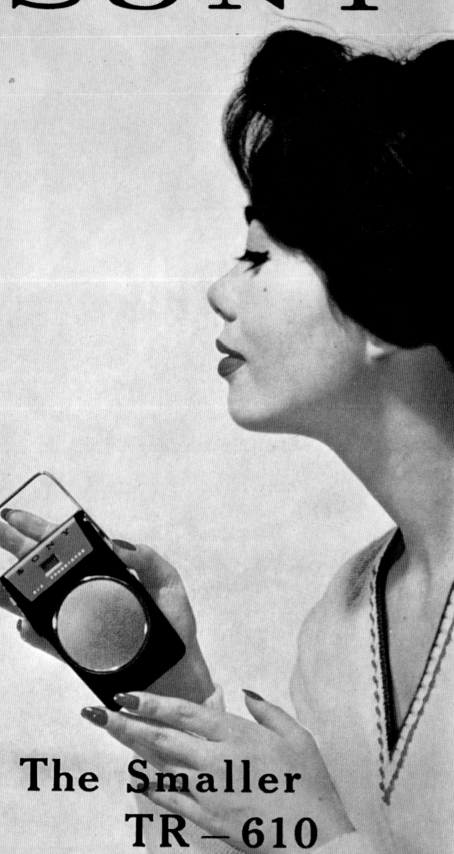

SONY

The Smaller
TR — 610

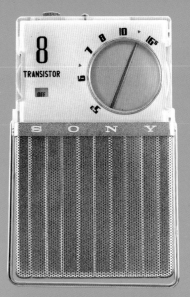

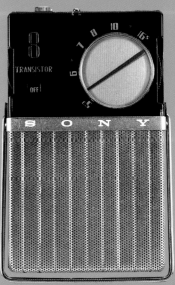

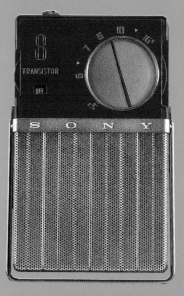

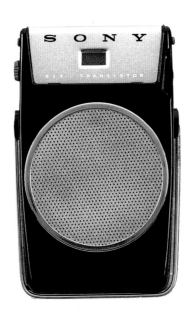

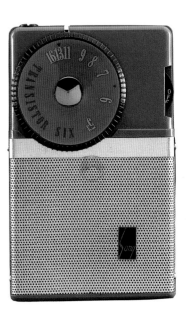

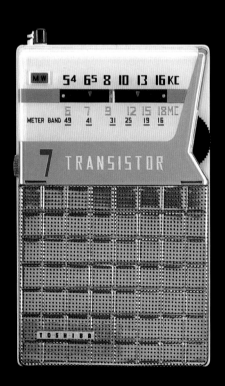

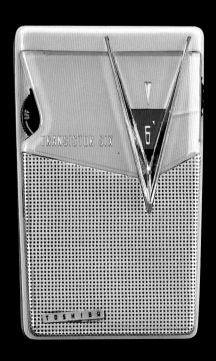

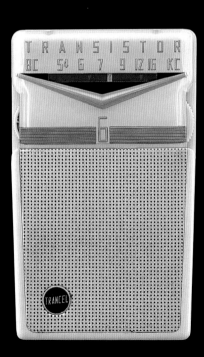

The first Japanese transistor radios enjoyed a phenomenal suc-cess in the American marketplace because of their portability, novelty, and moderate cost. Consequently, many Japanese man-ufacturers of electronic goods jumped into the fray. Sony's rivals included Toshiba, Hitachi, Sanyo, Mitsubishi, and Matsushita, while a host of lesser-knowns competed with models bearing such names as "Hurricane," "Jupiter," and "Tonepet."

A Japanese trade journal reported the surge in the market-place. "The grand total of electronic [sic] products exported in fiscal year of 1958 amounted [sic] 15,900 million yen compared with 1957 total export of 6,300 million yen indicates [sic] 2.5 times increase.... Radio receiving sets ... represented 77% of the total." Half of Japan's total output ended up in the United States.

The transistor radio had taken off, and with it came the for-tunes of many Japanese manufacturing companies that went on to become the industrial giants of the world that they are today.

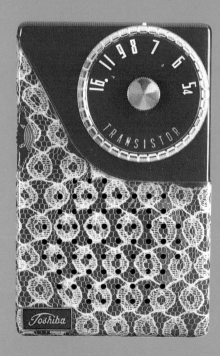 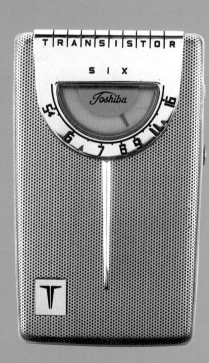 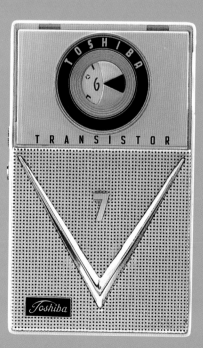

HITACHI

TRANSISTOR 6

OFF

8 7 6 5 4 10 12 16 9

Like Toshiba, who indeed

manufactured everything "from turbines to transistors,"

Hitachi was – and still is – a major

player in Japanese industry. The designs of Hitachi's

radios compare favorably to

those of the other titans.

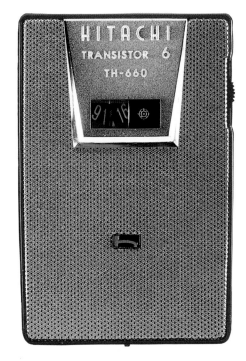

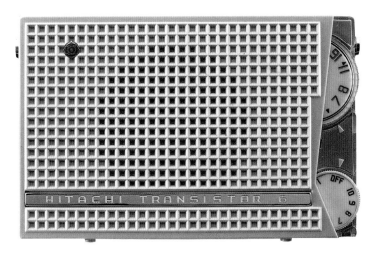

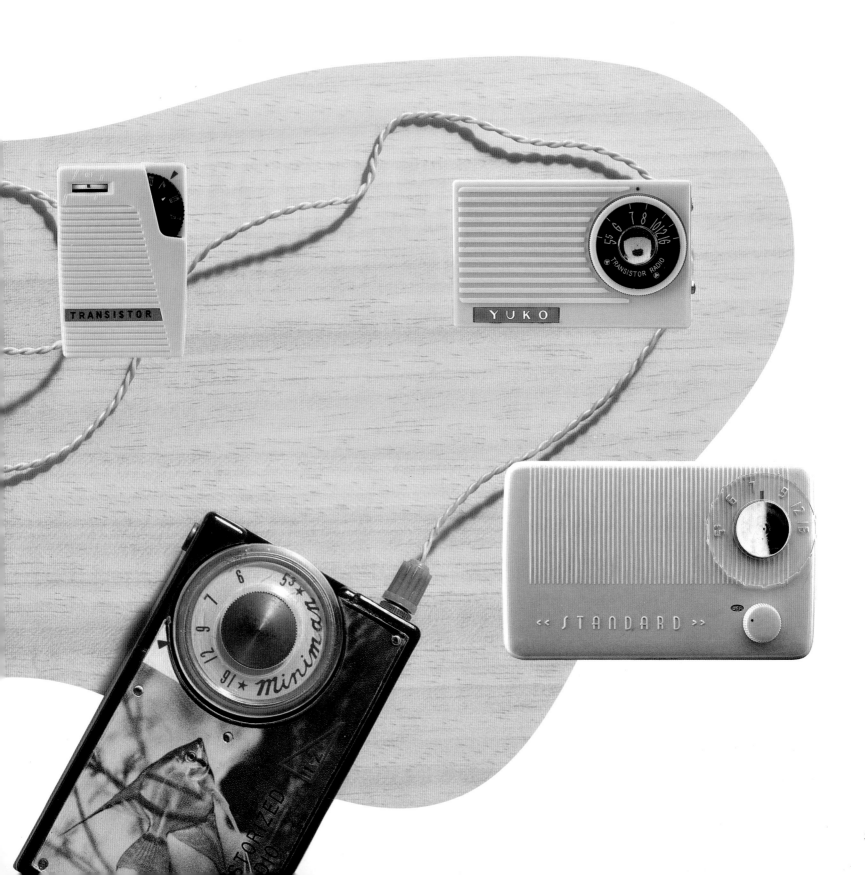

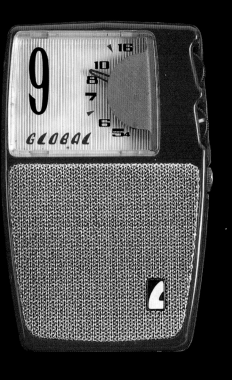

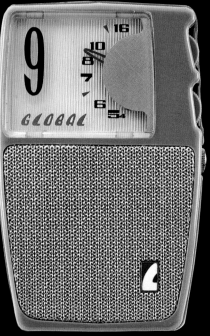

G l o b a l

Global radios did not enjoy the same

degree of international visibility or brand longevity

as Sony and some other competitors,

but they eclipse many a better-known make

in beauty and detailing.

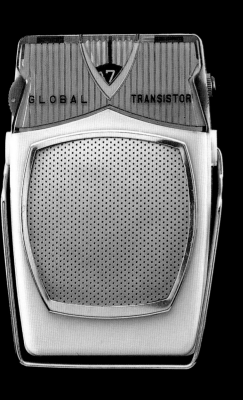

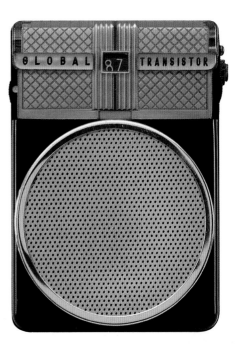

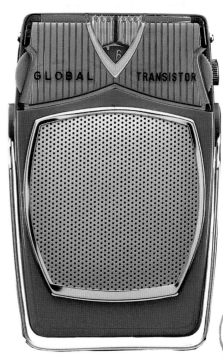

The horizontal orientation of these elegant NECs, while not unique, was unusual for shirt-pocket

micros and minis micros and minis

HONEYTONE
6 TRANSISTORS

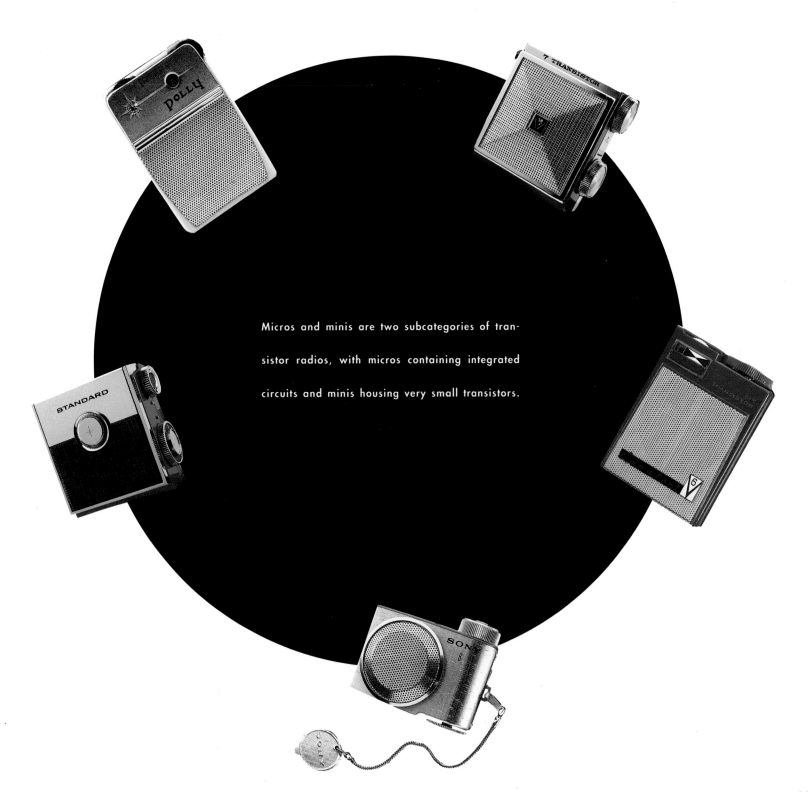

Micros and minis are two subcategories of transistor radios, with micros containing integrated circuits and minis housing very small transistors.

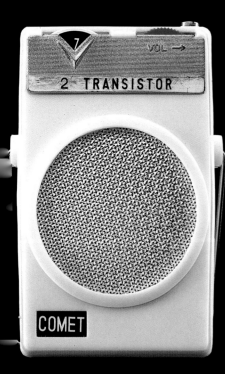

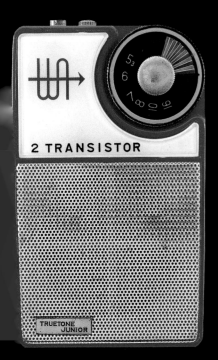

2 - T R A N S I S T O R

Toy Radios

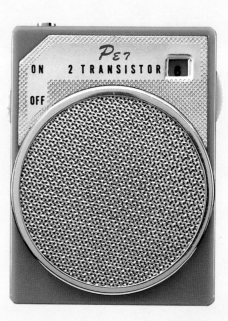

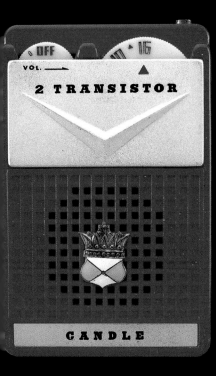

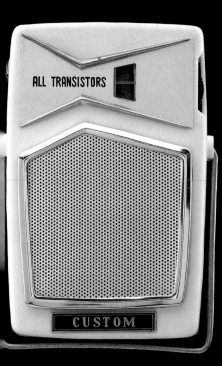

Two-transistor Toy Radios were not "make-believe" ra-

dios. They were the real thing, only less so. Also called

"Boy's Radios," these radios contained four less than

the usual six transistors. By being classified as toys,

these products were placed in a separate export cate-

gory and were subject to lower duties both when leav-

ing Japan and entering America. This category proba-

bly emerged as a creative way for Japan to continue

to slake America's intense thirst for transistor radios.

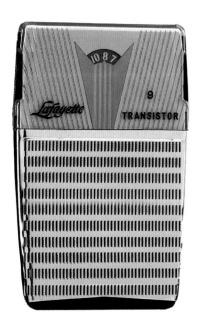

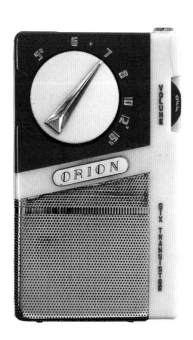

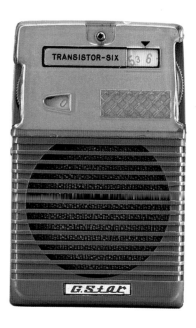

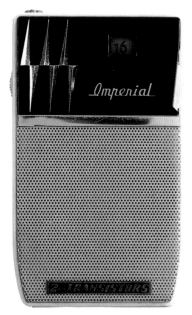

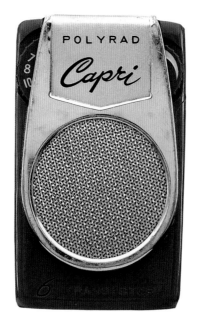

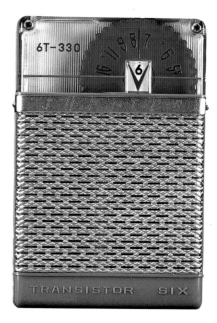

OFF BRANDS

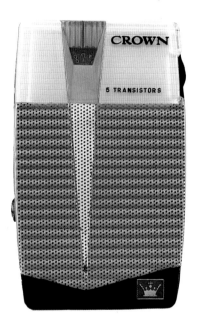

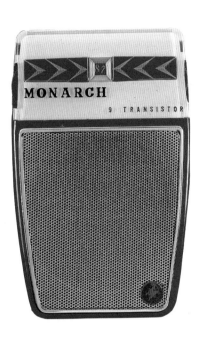

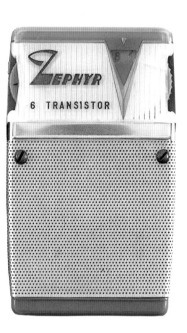

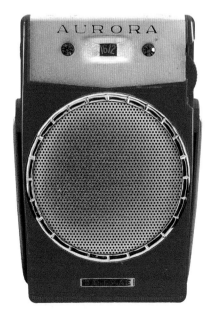

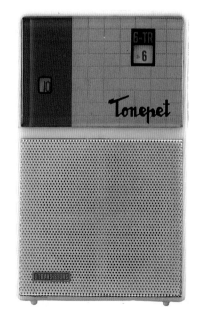

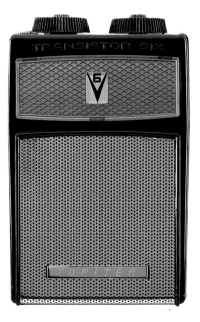

All Brands

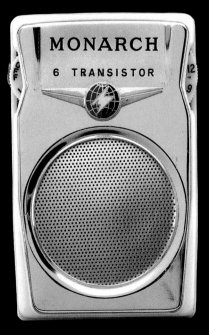

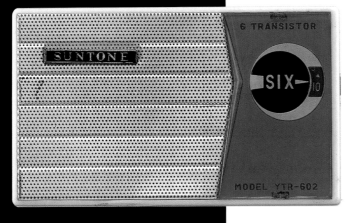

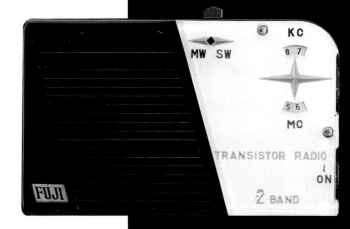

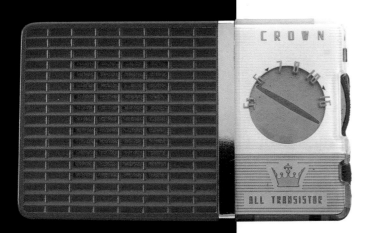

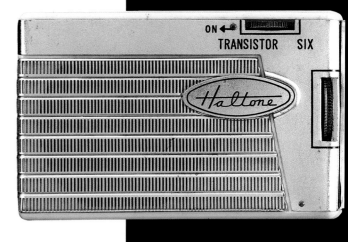

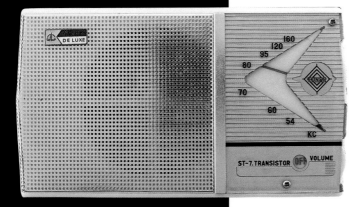

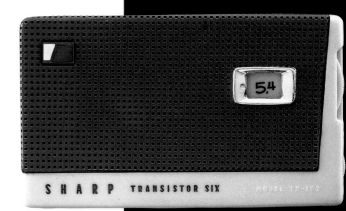

POPULAR

Tuned In The timing of the Japanese radio's incursion into U.S. markets

couldn't have been better. Many forces converged to make an instant success of the transistor

radio: An unprecedented number of young people, courtesy of the post-war baby boom; a

period of prosperity with seemingly unlimited buying power; an appreciation of leisure time.

Oh yes, and the emergence of something called "rock 'n' roll." *Musical America* had this to

say about rock 'n' roll in March 1957, under the banner "Passing Fad": "At best rock 'n' roll

is a kind of glorified hillbilly music with a two-beat, familiar twanging guitar and a grotesque-

ly distorted vocal line picked up from the blues ... it is merely a convenient vent through which

a gravely disturbed and uncertain generation can release and externalize its inner tensions."

TRANSISTOR

2

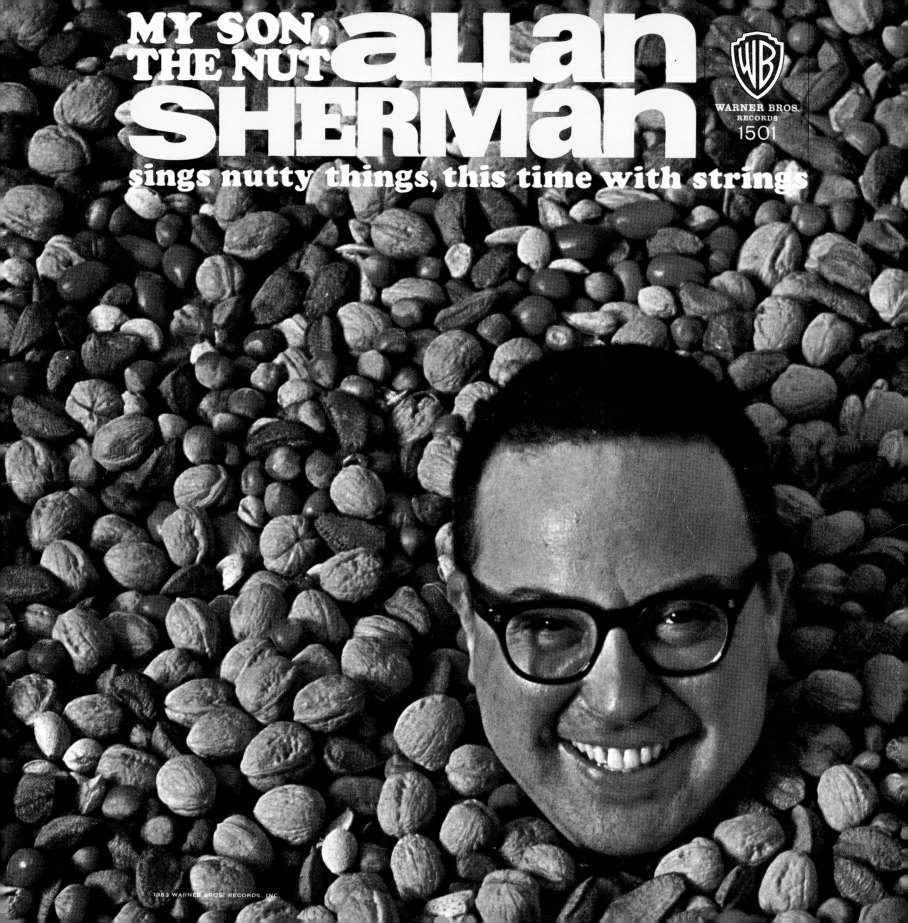

Funnyman Allan Sherman spoofed "The Twelve Days of Christmas," and replaced "... a partridge in a pear tree" with "... a Japanese transistor radio."

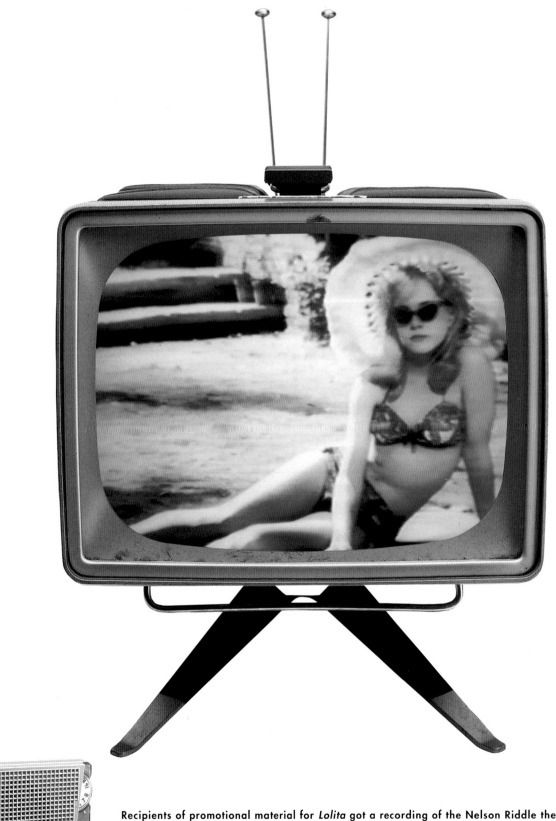

Recipients of promotional material for *Lolita* got a recording of the Nelson Riddle theme that actually played on the nymphet's radio. This still and the photo on the following page are inset into TV's of the period.

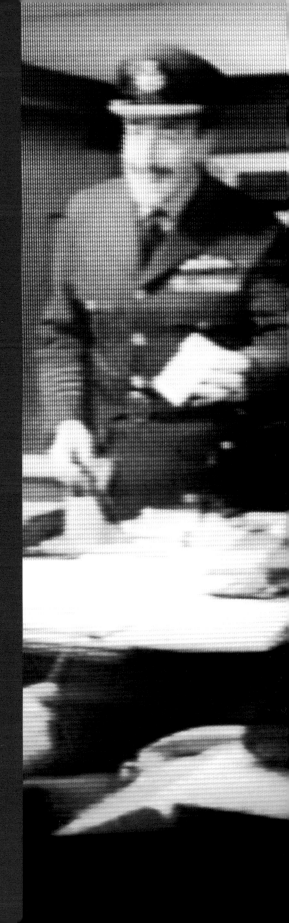

Unbeknownst to the keepers of the flame at *Musical America*, the times they were a-changin' ... inexorably. And the transistor radio was there. It figured prominently in popular culture by the sixties and seventies; in fact, a casual analysis of the movies, music, and fashion in which it appeared foretells major shifts in American values that would bring about enormous changes later in the decade.

The transistor radio starred in: *Lolita*, based on Nabokov's book (published to outcry in America), which could not have even been thought of as a movie until a permissiveness prevailed; *Dr. Strangelove: Or How I Learned to Stop Worrying and Love the Bomb*, a brilliant black comedy by Stanley Kubrick, in which a paranoid Air Force general launches an unprovoked nuclear attack against Russia; *Hud,* in which a boy on the threshold of manhood is caught between generations and morals as he sees his grandfather's strict code of honor derided by his uncle, who himself is descending into debauchery (aided and abetted by a pink Cadillac convertible, of course); and Van Morrison's "Brown-Eyed Girl," a mystical, drug-oriented foray into nature.

The transistor radio is Lon's (Brandon DeWilde's) companion and solace as he sees his extended family (Paul Newman, Melvin Douglas, and Patricia Neal) disintegrate before his eyes in *Hud*. [American iconography abounds in this reconstruction of Lon's Levi's jacket and radio, coincidentally now both objects of collector interest.]

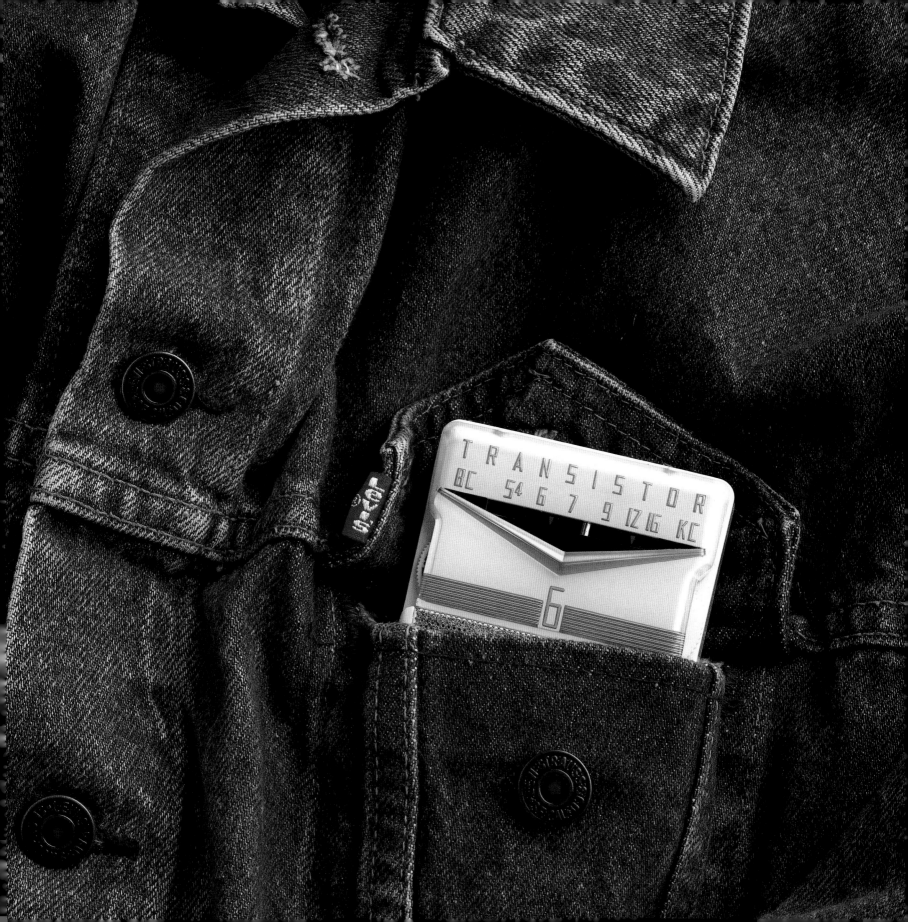

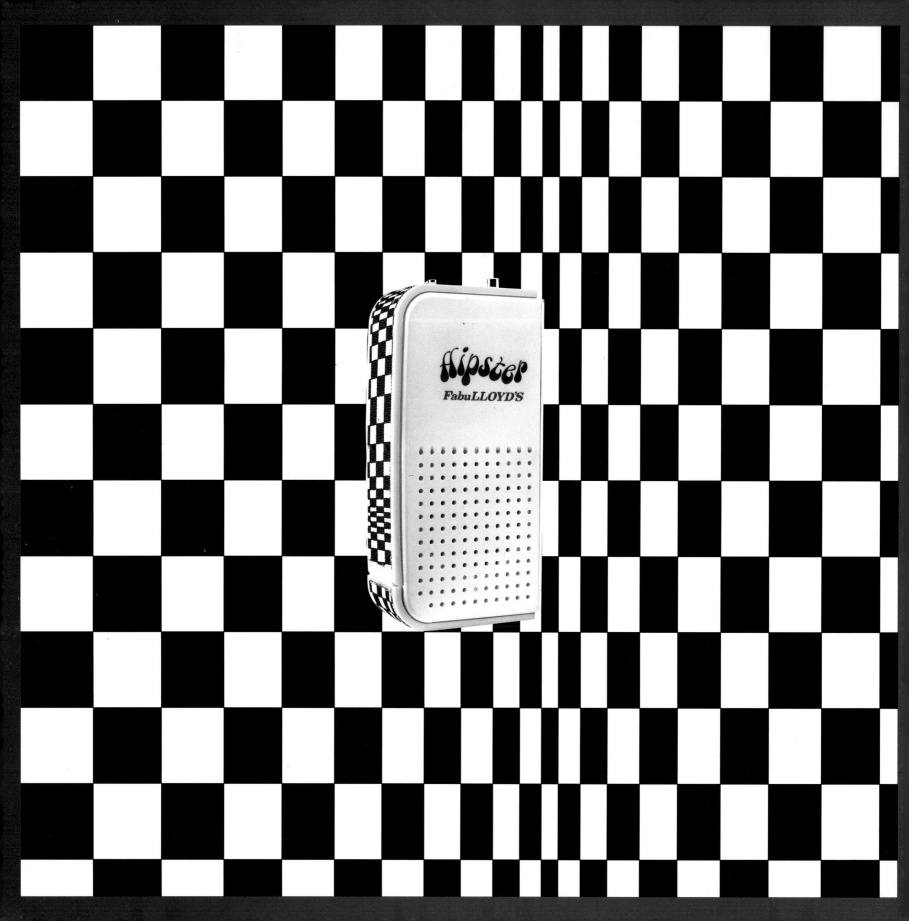

A fashion statement worth noting was the "Hipster" transistor radio. It co-opted "retinal excitement" op art, an art form previously associated with the counterculture and psychedelic drugs. Now it could be found under the Christmas tree, courtesy of Grandma.

Let's see ... a growing discontent about the nuclear threat, the disintegration of family, America's lost innocence, loosening mores, a devaluing of revered institutions, experimentation with mind-expanding drugs. Hmmm, did the transistor radio miss any major movement of the sixties?

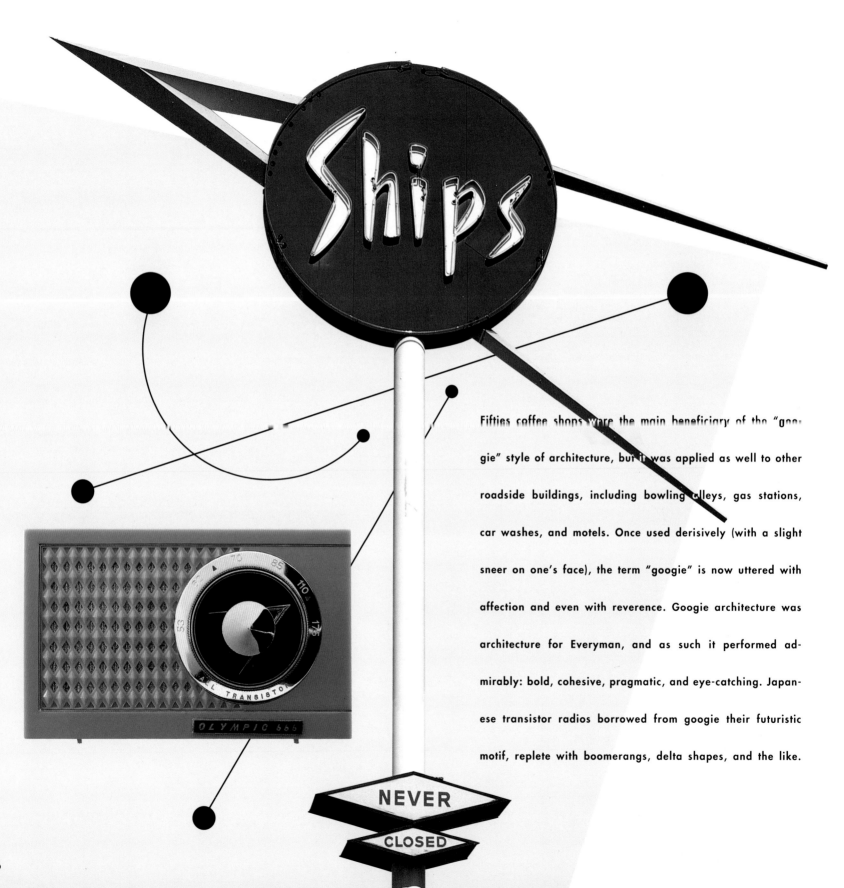

Fifties coffee shops were the main beneficiary of the "goo-gie" style of architecture, but it was applied as well to other roadside buildings, including bowling alleys, gas stations, car washes, and motels. Once used derisively (with a slight sneer on one's face), the term "googie" is now uttered with affection and even with reverence. Googie architecture was architecture for Everyman, and as such it performed ad-mirably: bold, cohesive, pragmatic, and eye-catching. Japan-ese transistor radios borrowed from googie their futuristic motif, replete with boomerangs, delta shapes, and the like.

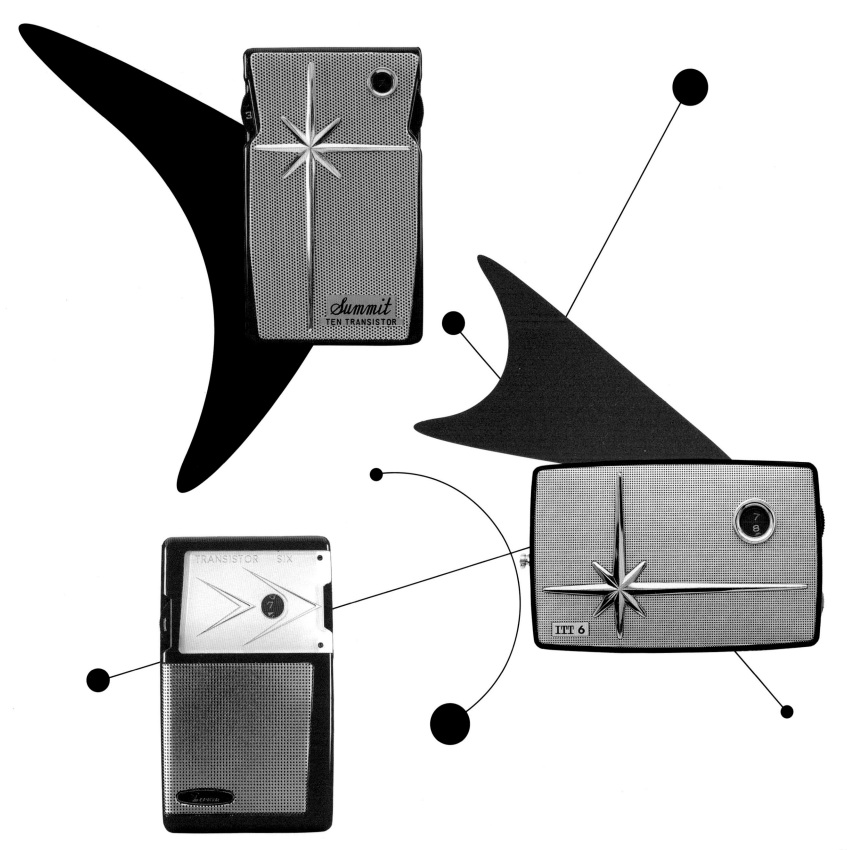

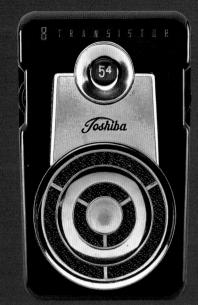

AUTOMOTIVE STYLE

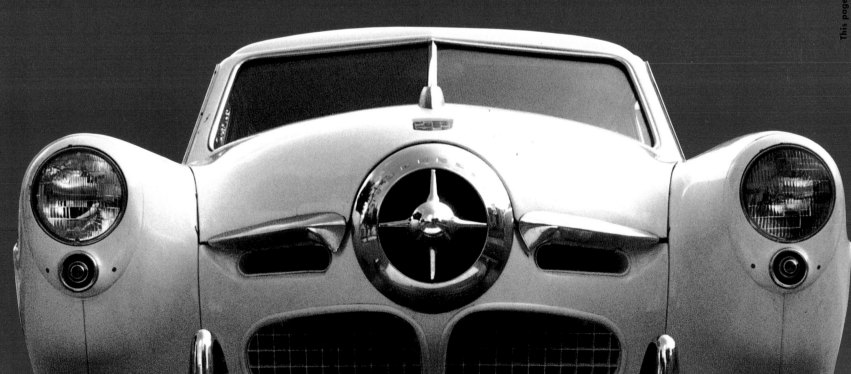

This page, car courtesy of Bob Haxby. Following pages, cars courtesy of Hollywood Picture Vehicles, Hollywood, CA 90038.

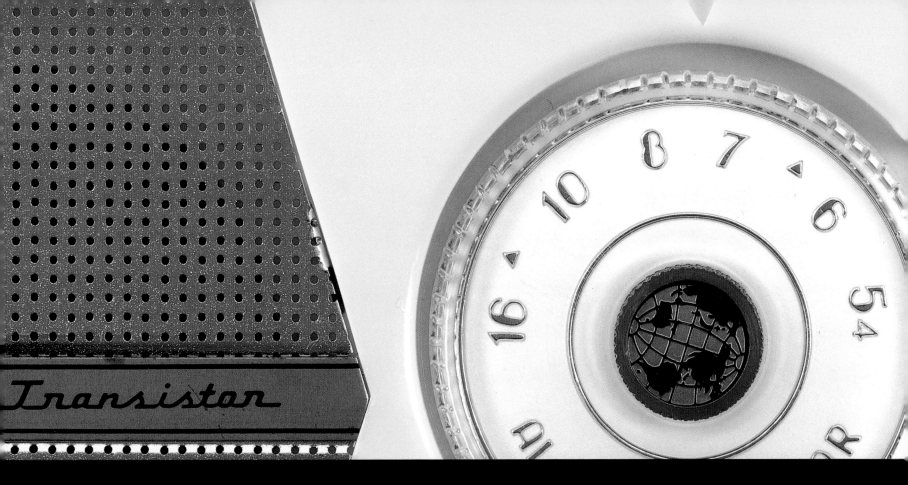

Transistor

Blast-Off When it came to designing high-technology electronic goods such

as transistor radios, the Japanese were temporarily at a loss. Though undisputed masters at their

traditional arts – disciplines such as architecture, graphic design, and dress, to which they could

apply their long-standing aesthetic concepts – electronics were nontraditional, manufactured by

foreign tools. Because, after all, America was the largest export market for transistor radios,

Japanese electronics companies looked to our popular iconography of the day for inspiration.

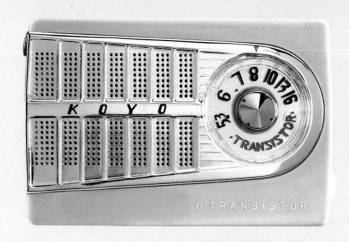

The automobile lured Americans with dreams of escape, adventure, and romance – dreams that came true even when

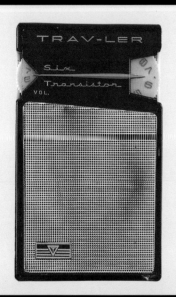
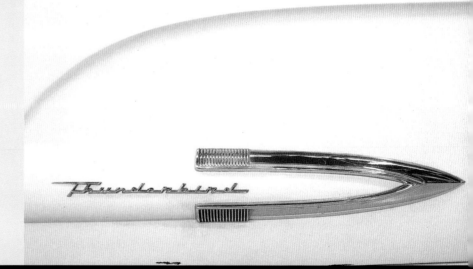

you just drove it to the local drive-in theater. Grace Kelly, scarf protecting her *trés soignée* coif, whizzed down

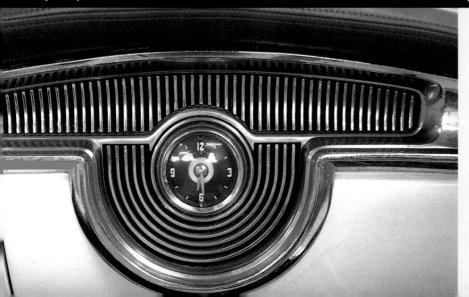
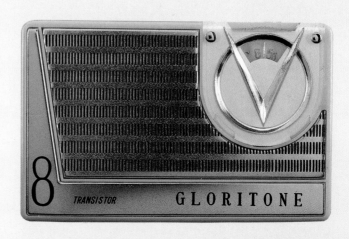

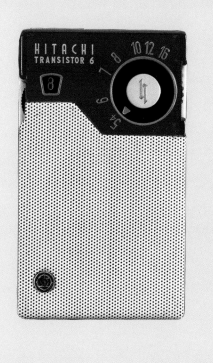

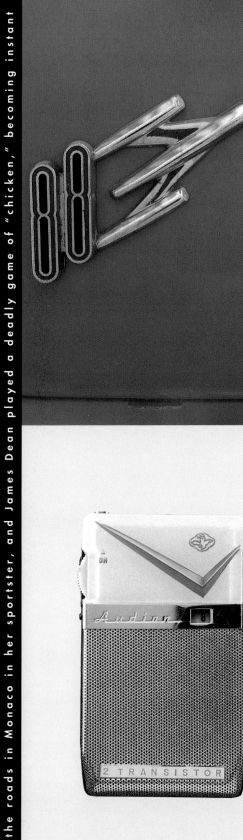

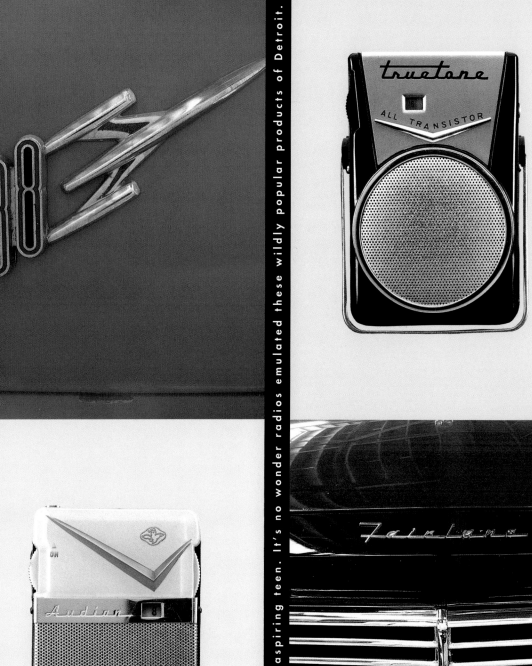

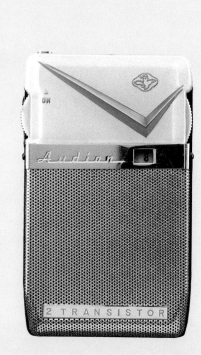

the roads in Monaco in her sportster, and James Dean played a deadly game of "chicken," becoming instant

role models for every aspiring teen. It's no wonder radios emulated these wildly popular products of Detroit.

6T-330

JUPITER

 What did they find? Boomerangs, flying saucers, starbursts, and atoms. To say the futuristic, space-age style was "popular" is perhaps an understatement.

It was emblazoned on autos and refrigerators. Coffee tables and coffee shops took their very shapes from it. Lampshades, curtains, and linoleum shouted it.

It was the gospel of modernity, embraced by a nation enthralled by the thought of jet and space travel. America was moving on, moving up, moving ahead, faster than the speed of sound! The gospel was first propagated by Detroit, which put "autodynamic" tailfins on cars and gave them names like Rocket 88, Comet, and Satellite. Then it infiltrated roadside eateries, which soared, unfettered by gravity, over their adjacent parking lots. Soon nothing would be safe from its grasp. Least of all transistor radios.

The radios were brimming with boomerangs (recalling the wing shapes of fighter planes), and studded with stars. Parabolic curves, mimicking a rocket's trajectory, abounded. Flying wedges dominated, like the sleek shape of the latest aerodynamic experiments. Even the names – Vista, Global, Orion, and Aurora, for example – spoke of the "great frontier" that we would soon conquer.

Nothing could stop us now!

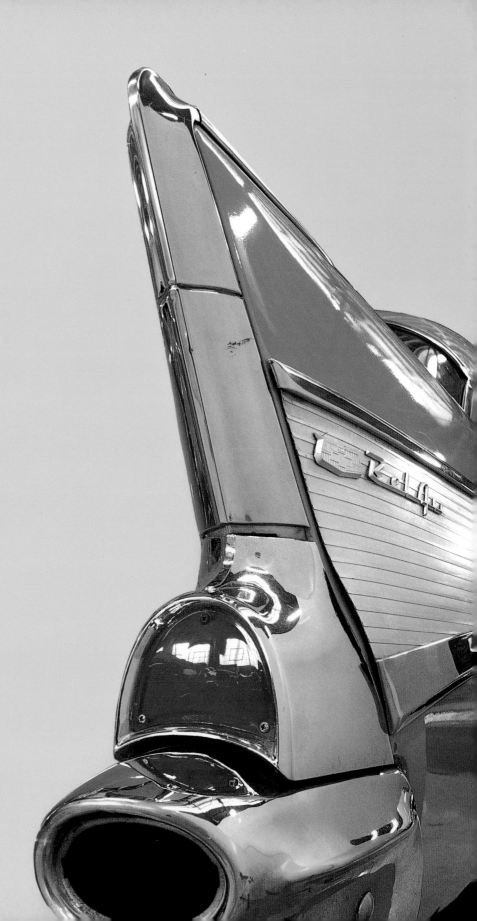

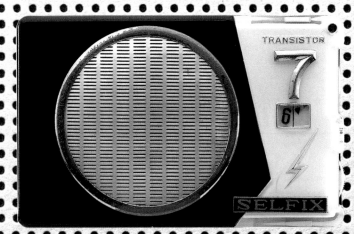

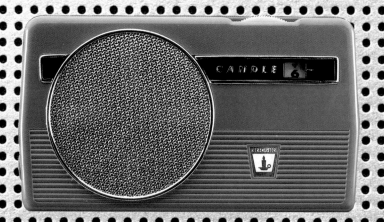

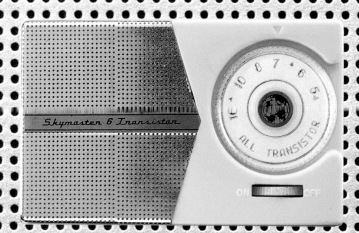

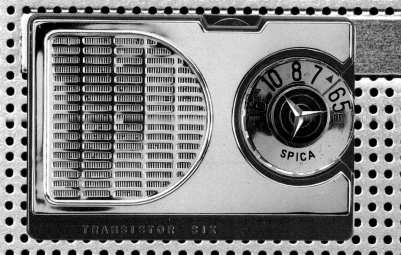

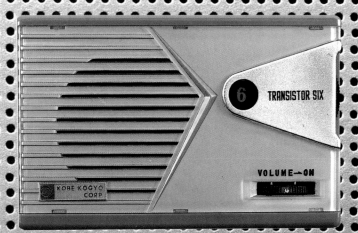

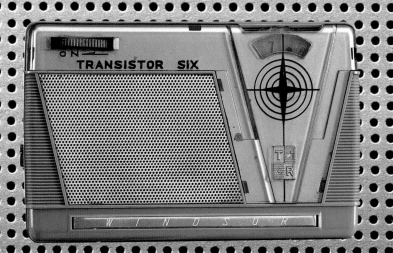

2-Band 8-Transistor

NATIONAL

The coat-pocket radio emerged in the early days of the transistor radio, mainly because the technology necessary to fit transistors into the shirt-pocket-sized housing had not yet been perfected. Even after shirt-pocket models were commonplace, American and Japanese manufacturers continued to make coat-pocket models to lend cachet to their radios. Coat-pocket models were considered to be of higher quality, with a bigger antenna and better pulling power. It is obvious that this style of radio was also heavily influenced by the space- and auto-inspired styles of the day.

Fleetwood, an off-brand Japanese make, produced particularly handsome radios. The minor variations found in each of the radios pictured here are just the nuances that continue to surprise and delight aficionados.

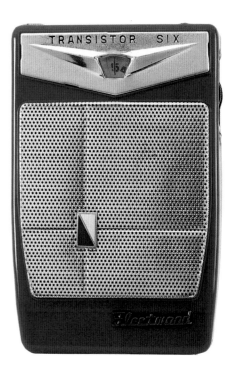

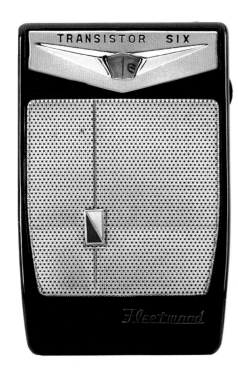

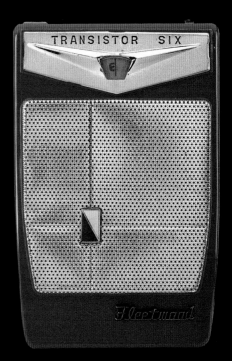

Novelty

Radio was revo-

lutionary indeed. Once the province of only the

wealthy, who held private recitals in their parlors, music now

belonged to everyone who could afford a radio. Puccini arias uplifted

the hard life of the recent immigrant. It brought quality entertainment and

sparked the imaginations of families across the country with fascinating

characters like "The Shadow." It was truly a tool of democracy, informing

and educating the "great unwashed" with offerings like Presidential "fire-

side chats." But only the most visionary could have ever imagined that

by the sixties "Purple People Eater" would be emanating from

a flying saucer or "Do the Bug" from ... a beetle?

How very extraordinary!

R S

A O

D I

68

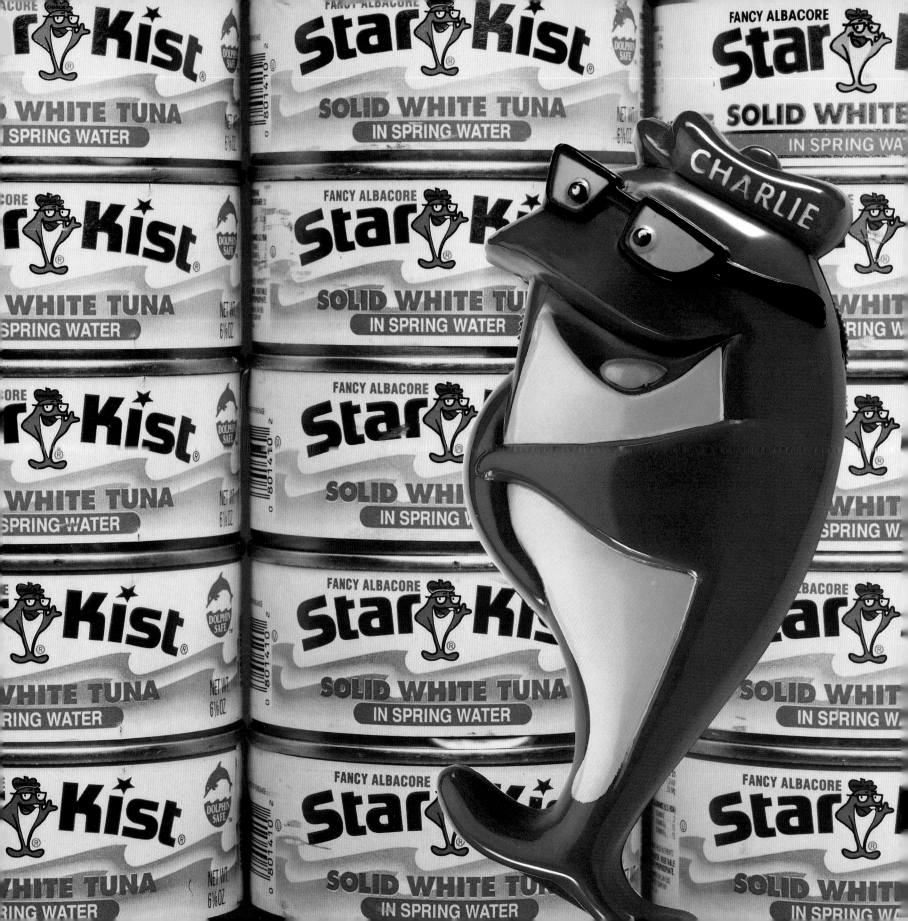

The transistor radio now could double as a novelty item. Designers realized its tiny components allowed them to deviate from the box and enclose them in an untold selection of figural housings. For many children, their first radio was one of these novelty sets. Corporations discovered their usefulness in advertising and promotion. For a nominal sum, you could send away to Star-Kist for your very own Charlie Tuna radio. As you proudly paraded it around town, Charlie – and Star-Kist – got enviable visibility.

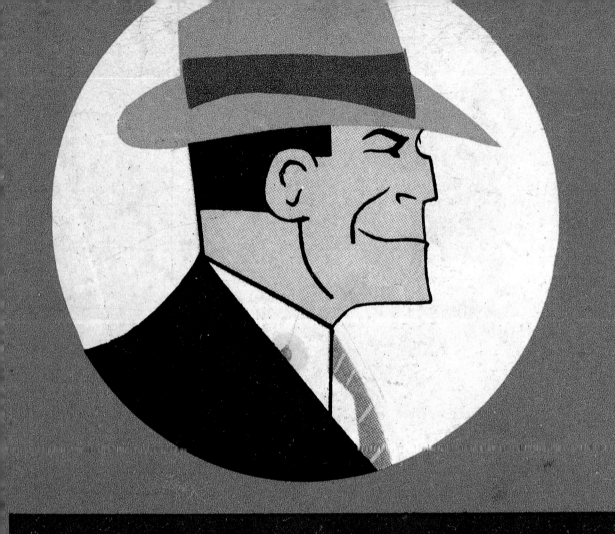

SHOULDER
HOLSTER

DICK TRACY ®

2 TRANSISTOR

RADIO RECEIVER

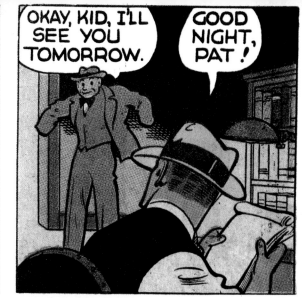

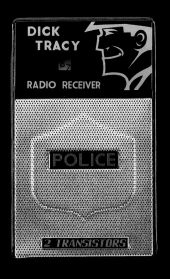

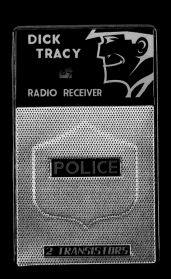

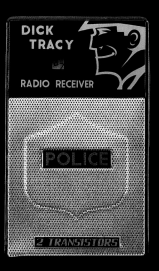

The square-jawed sleuth Dick Tracy captured the imaginations of generations of readers, from his debut in 1931 in Chester Gould's

comic strip to his big-budget incarnation in the 1990 film starring Warren Beatty. And what do young lads admire most about Dick

Tracy? His signature wrist-radio, which has been a favorite toy since the crystal set kits of the thirties allowed you to build your own.

Designer and architect George Nelson once asserted, "An educated individual is better equipped to deal with novelty than one who is not." Instead of scoffing at it, one should embrace and enjoy novelty, as it holds insights into what a culture considers important. These novelty sets give hints about our national pastime and our adulation of the movie-star mystique, our love of practical jokes and our interest in the ever-shrinking globe.

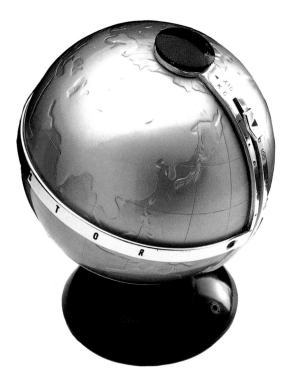

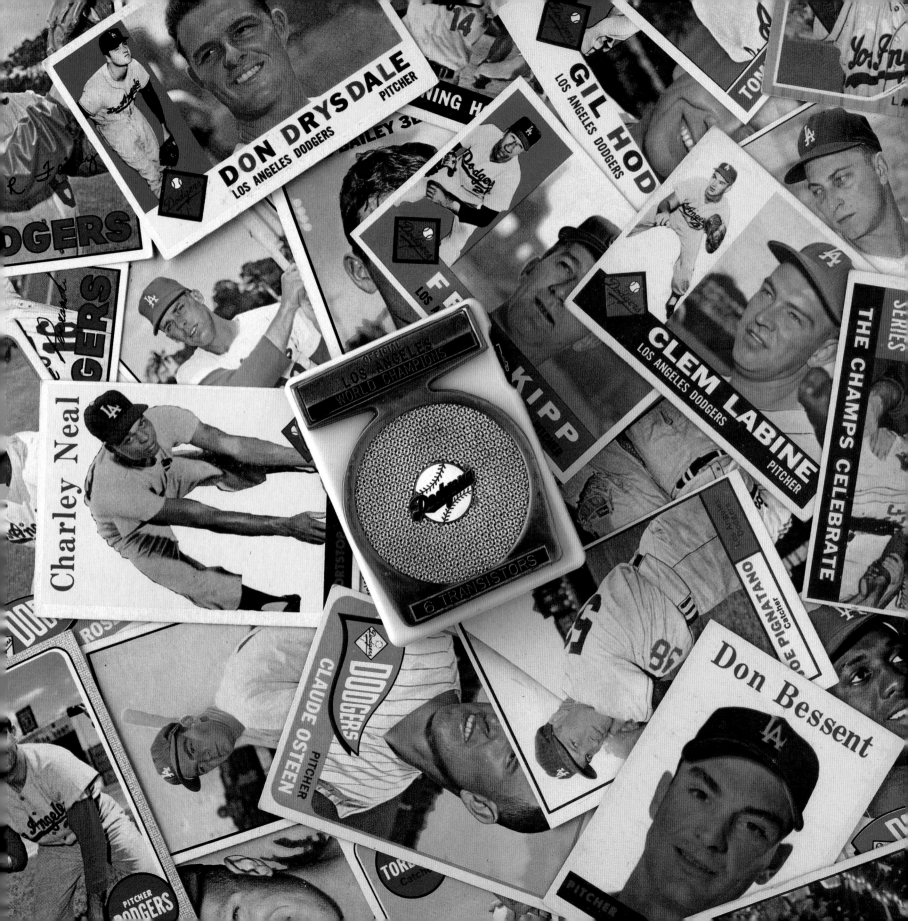

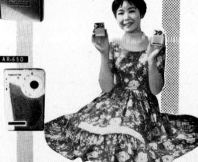

TRANSISTOR 7

2

ADVERTISING AND PACKAGING

"Anytime! Anyplace! Your boon companion" ... "Relax yourslf [sic] to these

transistorized masterpieces ... at home or outing" ... "Best excellent for appreciation of music! Best fit for

admiration in sitting room" ... "Good tone make you up good mood." How could anyone resist these quaint

exhortations? Although the Japanese effectively borrowed dominant American motifs for the design of their

transistor radios, the advertising and packaging of them for the American market was a different story.

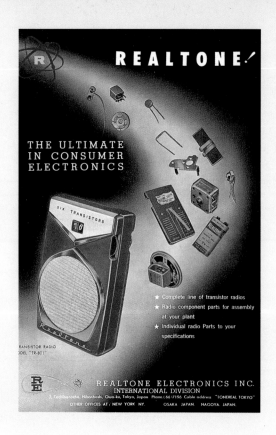

By and large in fractured English, ads were

unfamiliar to the reader in their gentle,

unassuming tone since American advertis-

ing had already taken on a brash quality.

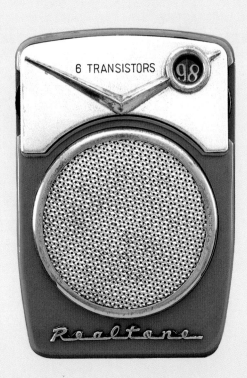

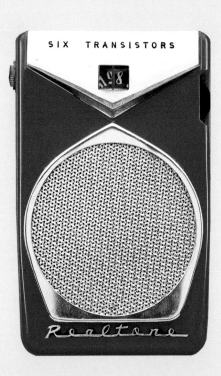

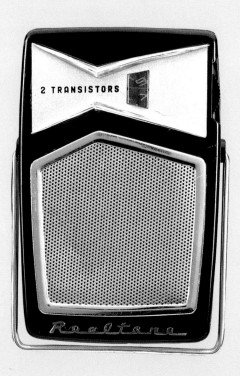

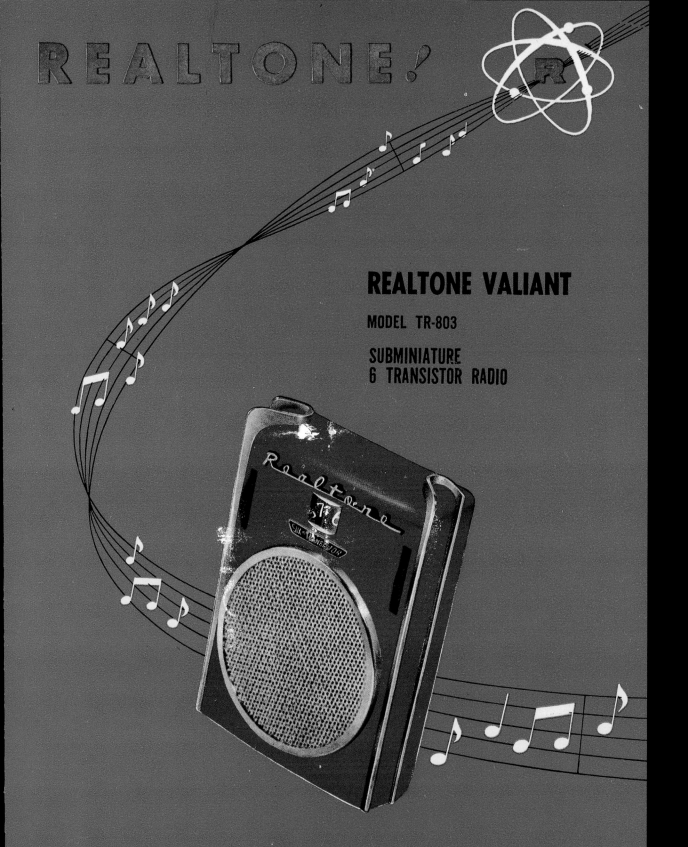

REALTONE!

REALTONE VALIANT

MODEL TR-803

SUBMINIATURE
6 TRANSISTOR RADIO

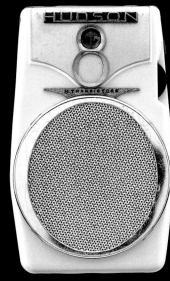

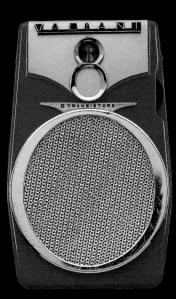

 REALTONE ELECTRONICS INC.

INTERNATIONAL DIVISION

look
at the size of it!

the incredible
TRANSISTOR 666 RADIO
by *HITACHI*

To our knowledge the smallest full-performance radio made ($2\frac{3}{8}$W x $3\frac{15}{16}$H x $1\frac{11}{32}$D). Though no larger than the palm of your hand, this Hitachi 666, with its 6 transistors and powerful dynamic speaker, is a giant in performance . . . operates indoors or out on a single, standard battery. Fully guaranteed.

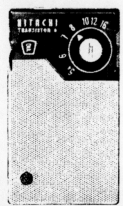

HITACHI, LTD.

VOLT

for introduction of Japanese electrical products & techniques

MAR
1960

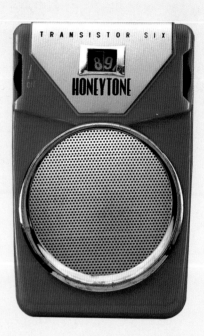

TRANSISTOR SIX

HONEYTONE

Automobiles, for example, were being advertised as an acquisition that would confer youth, beauty, popularity, and status on the buyer. Ads from Japanese radio manufacturers, on the other hand, portrayed radios as the thing to have because they were "congenial companions" or "a lovely mascot," or because the radio would improve your mood or enhance your surroundings. Typically a demure, attractive Japanese female lovingly caressed the radio. (Perhaps the ad that reflects a more American sensibility was the one that said it outright: "With quality of 6-transistor's, unique design and the price 3 times as cheap....")

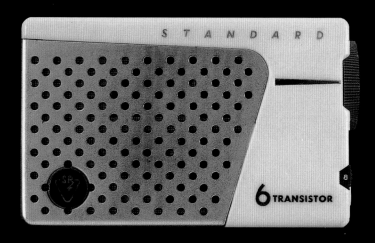

TRANSISTOR RADIO INDUSTRY IN JAPAN

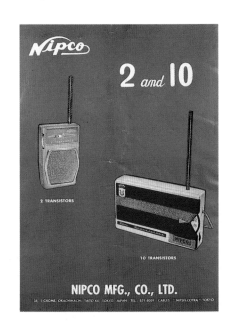

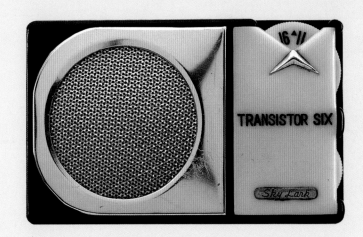

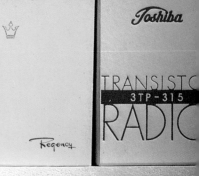

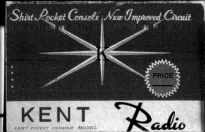

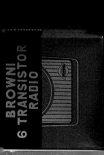
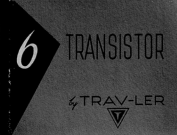

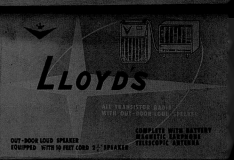

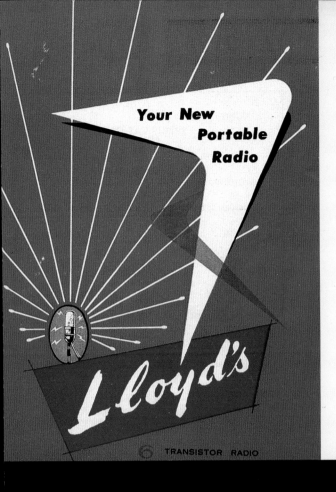

Your New Portable Radio

Lloyd's

⑥ TRANSISTOR RADIO

Early Japanese advertising and packaging didn't demonstrate a great deal of research, but in those days, when the goal was to spur the Japanese economy at the fastest rate possible, research and sophisticated methods were luxuries. These examples do evoke, though, a nostalgia for a simpler, more ingenuous time, a time before market research, the focus group, and ratings took the personality out of promoting products.

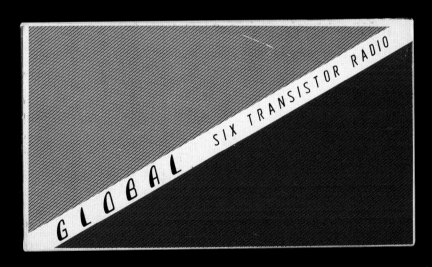

GLOBAL SIX TRANSISTOR RADIO

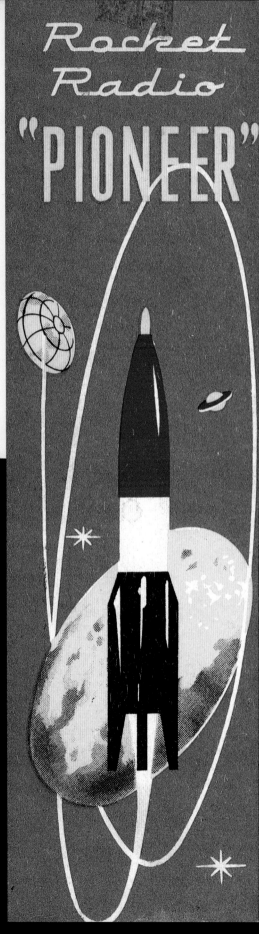

Rocket Radio "PIONEER"

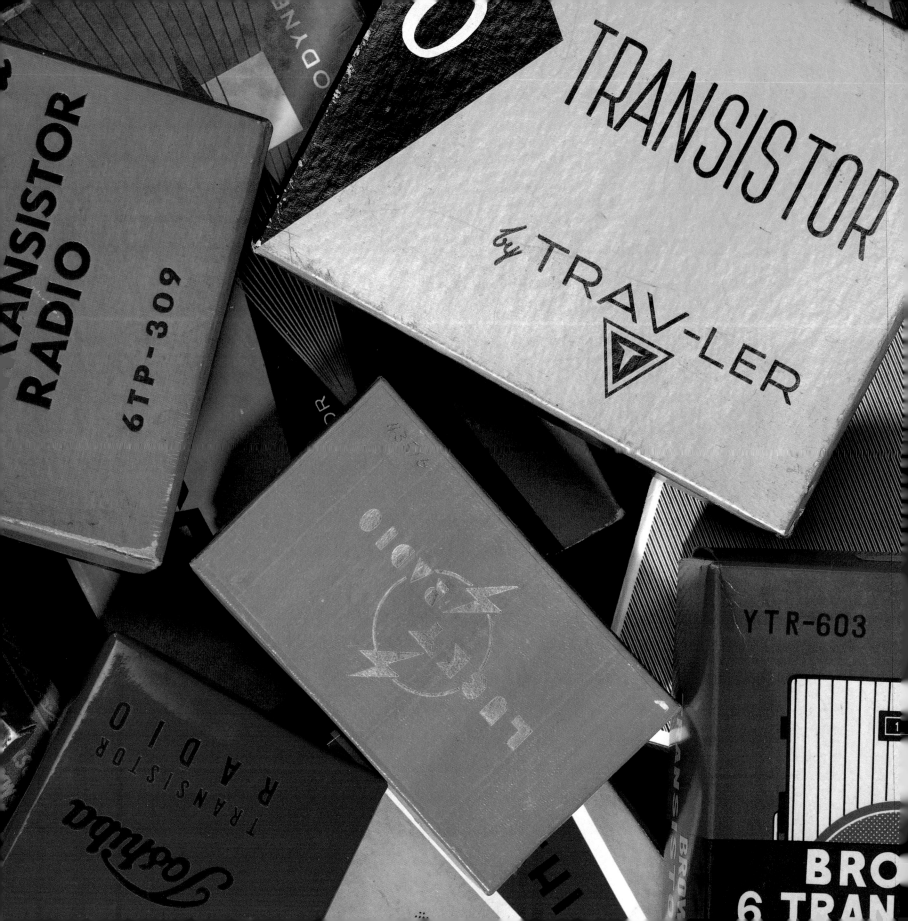

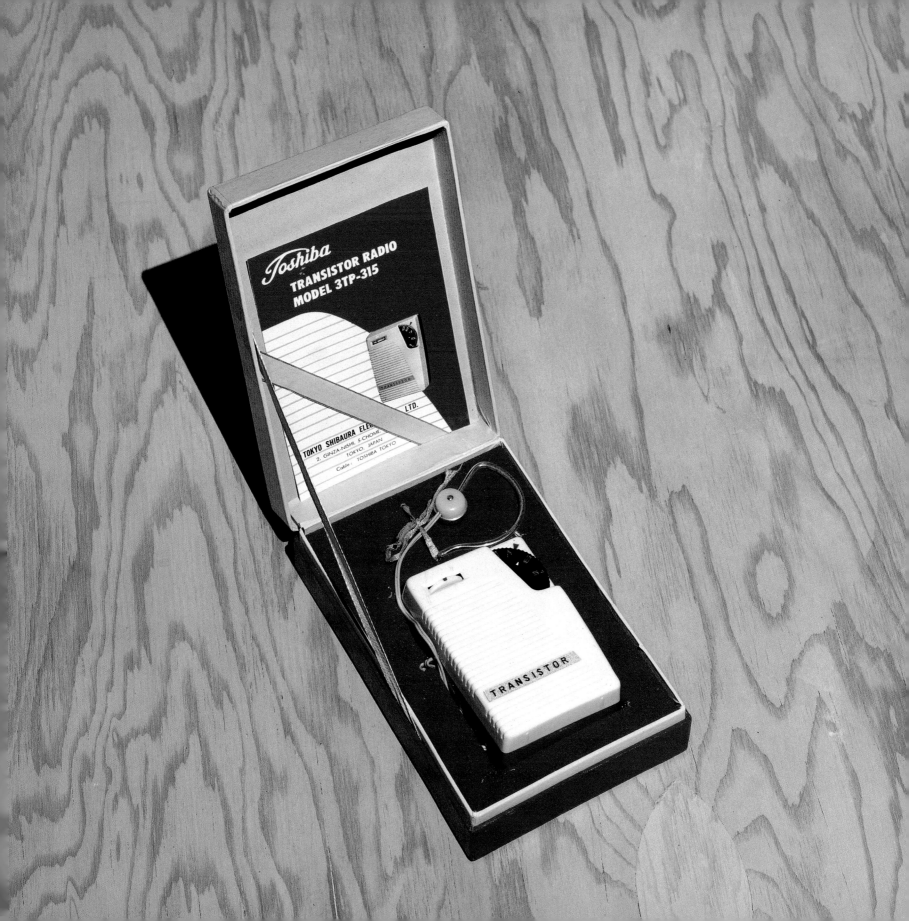

Hi - Lites "To see a World in a Grain of Sand/And a Heaven in a Wild Flower/Hold infinity in the

palm of your hand/And Eternity in an hour." With the exception of William Blake (and General Motors workers, who

"sweat the details"), we Westerners tend not to dwell too much on the specific. When we first appraise a garment,

for example, we'll note how it hangs – its overall structure and flow. Easterners, on the other hand, are apt to start

their assessment at the buttons. This "way of seeing" is a fundamental cultural difference between East and West.

D E S I G N

In *Modern Japanese Design*, Penny Sparke illuminates this point by drawing on the significance of the floor mat, which

acted as a standard unit of measure in traditional Japan and is still widely relied upon as a point of reference. "The

size of each room is described by the number of mats contained within it. In turn, the size and proportions of the

house itself are determined by the repetition of this module in the wall panels. This emphasis in Japanese living of fo-

cusing on the single unit first, and then on the outer shell has created a very particular Japanese way of understand-

ing form which operates by moving from the inside to the outside, from the detail to the whole, from the microscopic

to the macroscopic."

D E T A I L S

In this chapter, we will zero in on the fascinating decorative touches on the radios – the lettering and trademarks,

nameplates and badges, grilles and carrying cases. We will also take a look at torrid two-tone combinations, which

colored the radios – as well as every other item from refrigerators to cars to coffee shops – in the fifties and sixties.

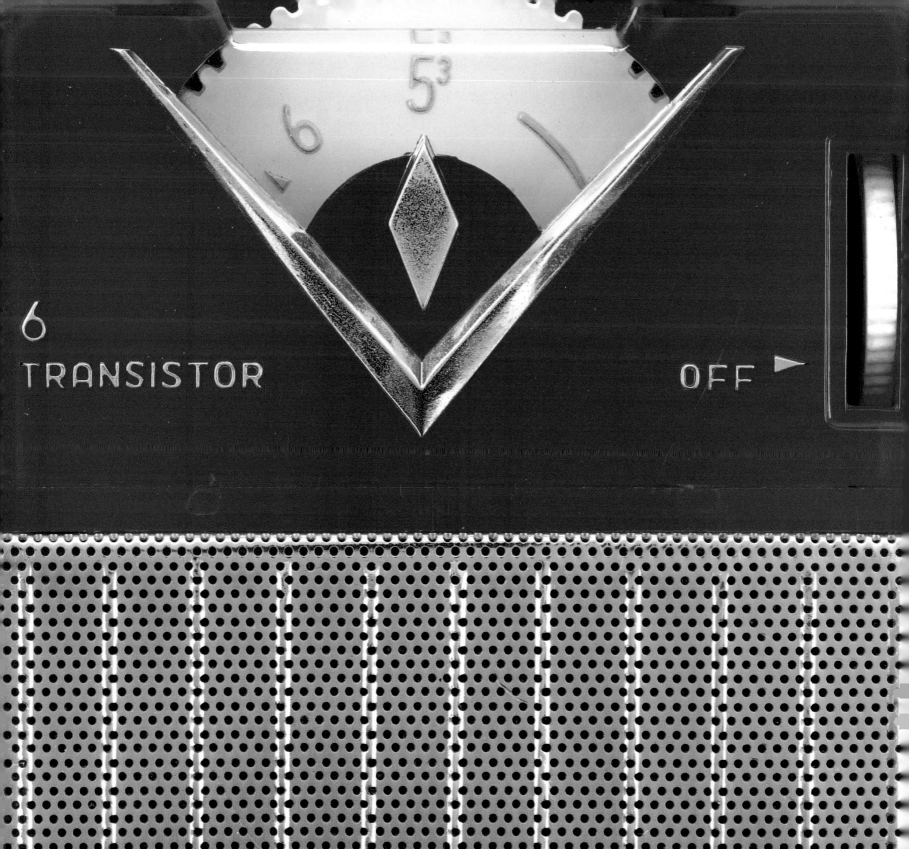

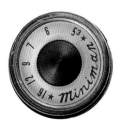

Look closely at transistor radios and you'll start to develop a micro-vocabulary of design highlights. You'll find

they speak the language of movement, borrowing details from the space race and auto-infatuation. With badges,

monograms, dials, delta shapes, wedges, flying Vs, all miniaturized, sometimes even in chrome.

Sharing names like Mercury, Comet, and Satellite, in typestyles similar to those of the nameplates on cars. These details endow a

futuristic look, an adventurous personality, speaking volumes about the American psyche.

Details

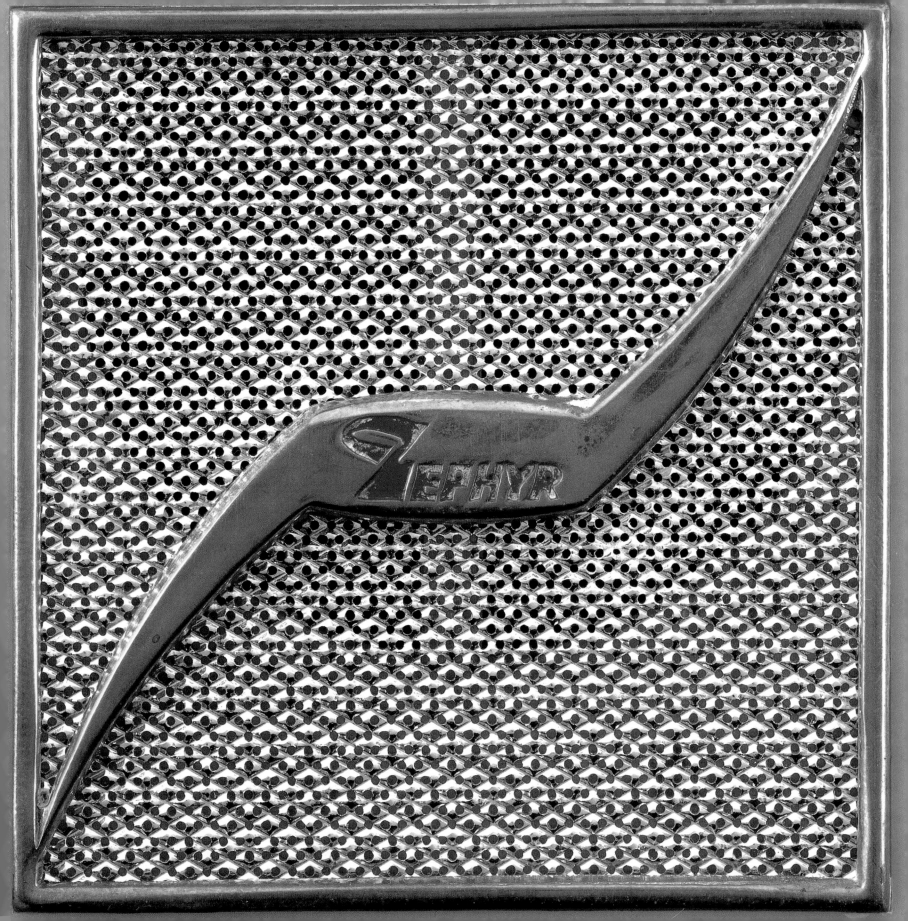

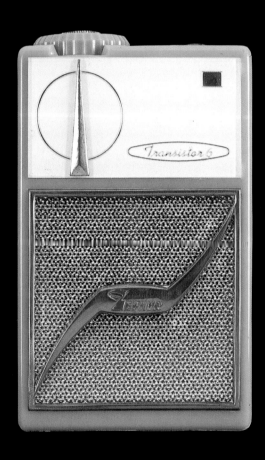

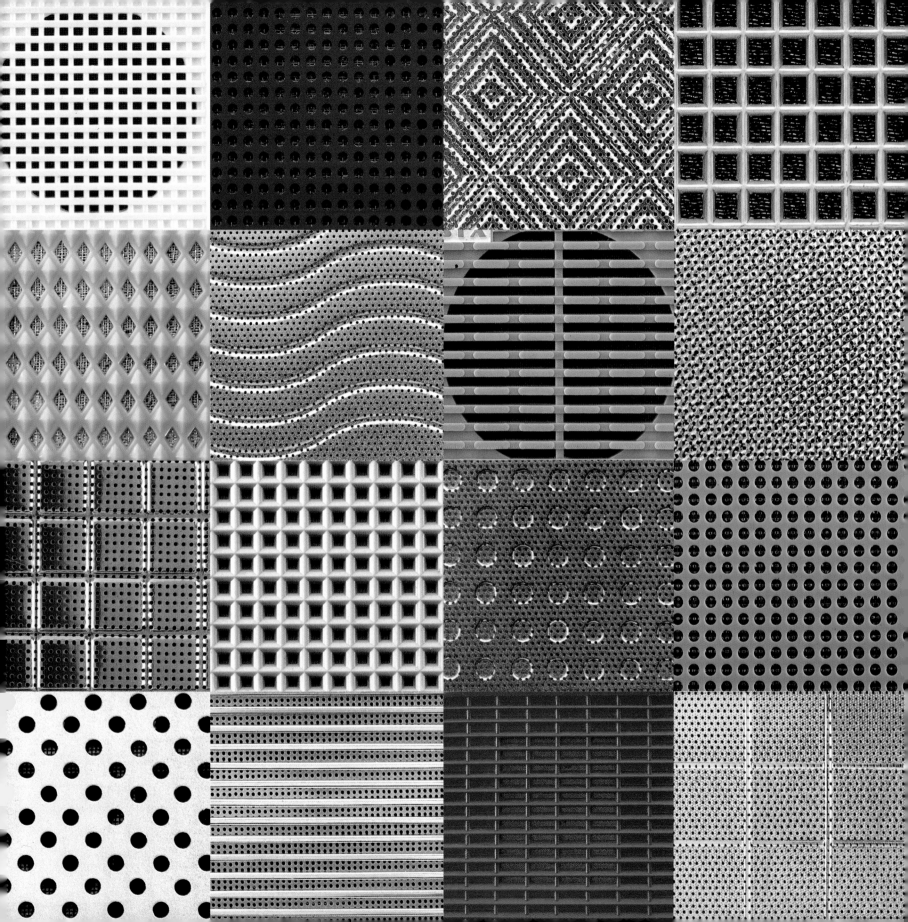

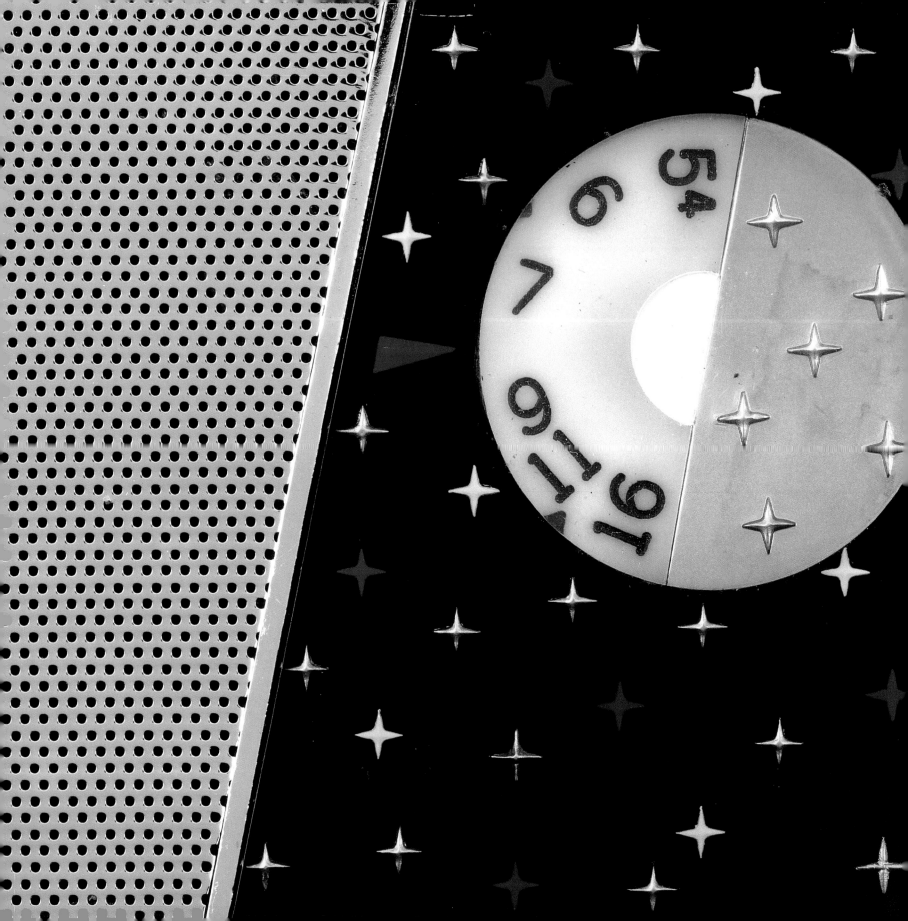

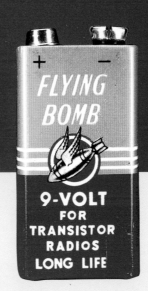

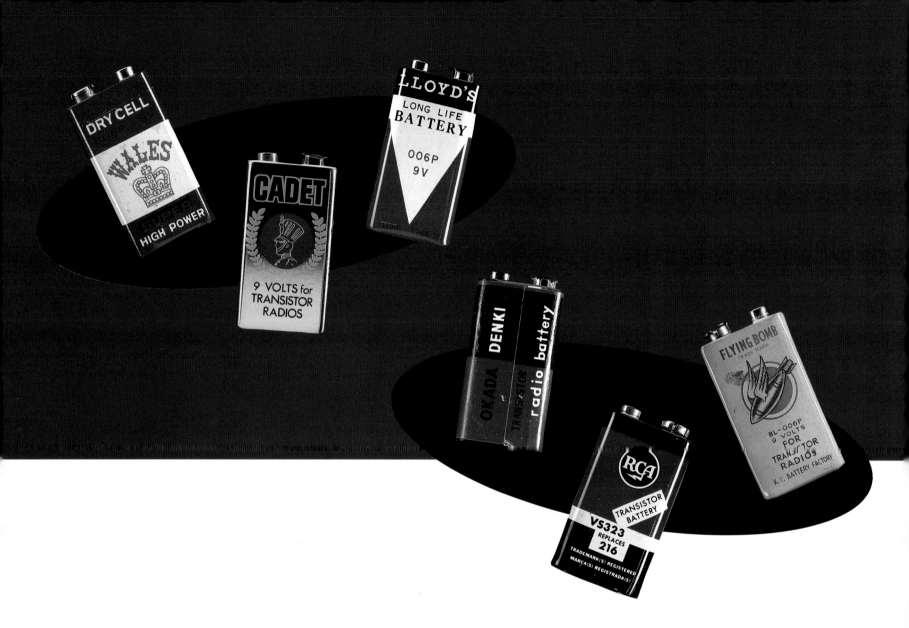

Batteries

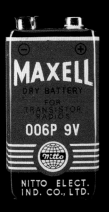

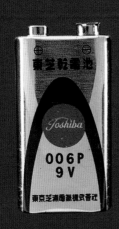

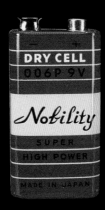

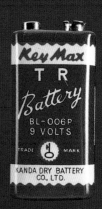

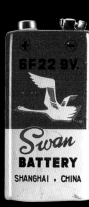

LONG LIFE

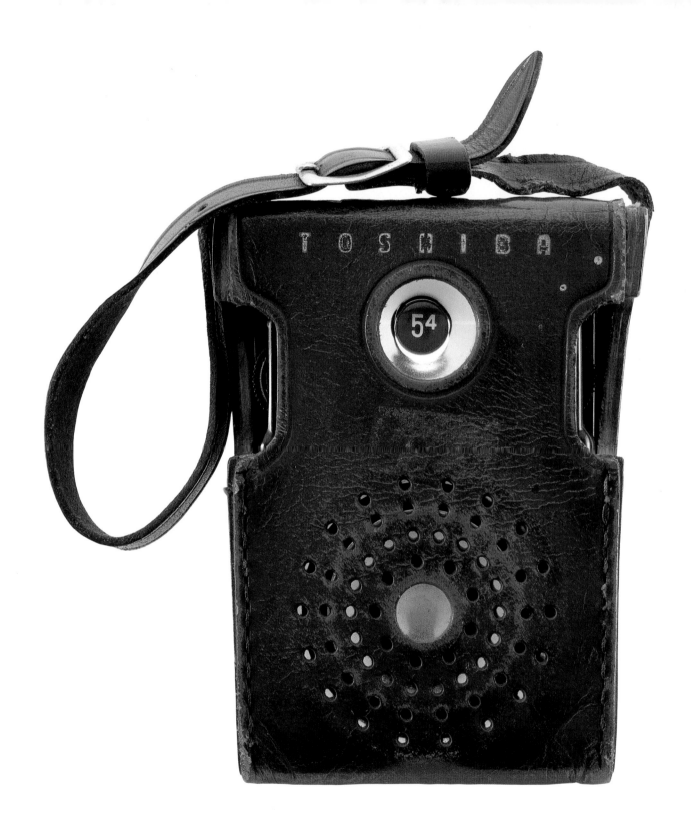

The case has the well-worn patina of a favorite leather jacket.

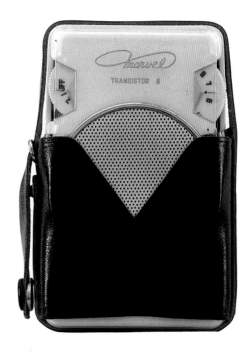

The heyday of the transistor radio was also the time

when "Gunsmoke," "Rawhide," "Maverick," and "Davy

Crockett" reigned supreme on the television. It should

surprise no one then that popular cases for the transis-

tors were, yep pardner, that's right, leather. Leather im-

parted that good old American, Grade A prime feeling.

MADE IN JAPAN

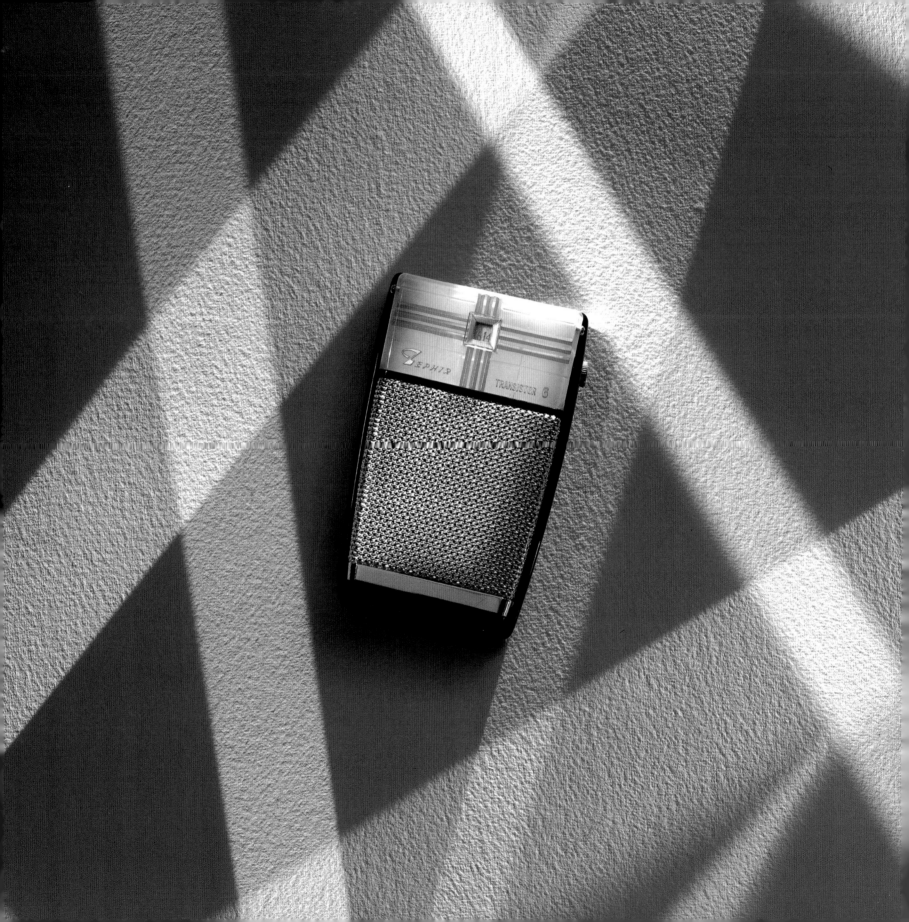

Charles Darwin mused in his journal, "It is enough to disturb the composure of the entomologist's mind, to contemplate the dimensions of a future catalog." Darwin was of course referring to insects, but he might as well have been talking about Japanese transistor radios, as many radios produced have

RADIO REBIRTH

not yet been discovered. Regarded as a disposable item, many prime specimens went the way of the trash can, but the species is far from extinct. At the time of this writing, the serious collecting of transistor radios has only begun in earnest; their continuing recognition by curators and collectors has ushered in a whole new enthusi-

asm for the subject. With the publication of a number of new radio-related books, magazines, and newsletters and the appearance of a growing number of collectors, the shirt-pocket transistor radio of the fifties and sixties is fast on its way to being rescued from dark cubbyholes and dusty cartons and afforded a safe haven, where it is certain to enjoy a new and deserved appreciation. Maybe the Japanese advertising angle was right after all. Maybe the transistor radio has become a treasured companion, a faithful mascot, a "tonepet." That is, they are loved, cherished, and held to the bitter end ... and then some.

Acknowledgments and Permissions

Special Thanks

Special thanks to: Modern Props, Inc., Los Angeles, CA for the TV's photographed on pages 50 and 52; Bob Haxby for the use of his Studebaker pictured on page 58; Hollywood Picture Vehicles, Hollywood, CA 90038 for the car details photographed on pages 58 – 63; Matt Federgreen, owner, Beverly Hills Baseball Card Shop for the baseball cards shown on page 75; Bill Burkett; Harald Herp; Serge Krauss; George Palmer; James D. Sowins; and good friends Parke and Susan. Very special thanks to: Dave Painter, Jim Teague, and the Petertil family, all of who supplied help with important historical information; author Michael Brian Schiffer; Eric Wrobbel for his loan of several prized articles; Rod Dyer; Tommy Steele; and especially Jim Heimann and Bill LeBlond.

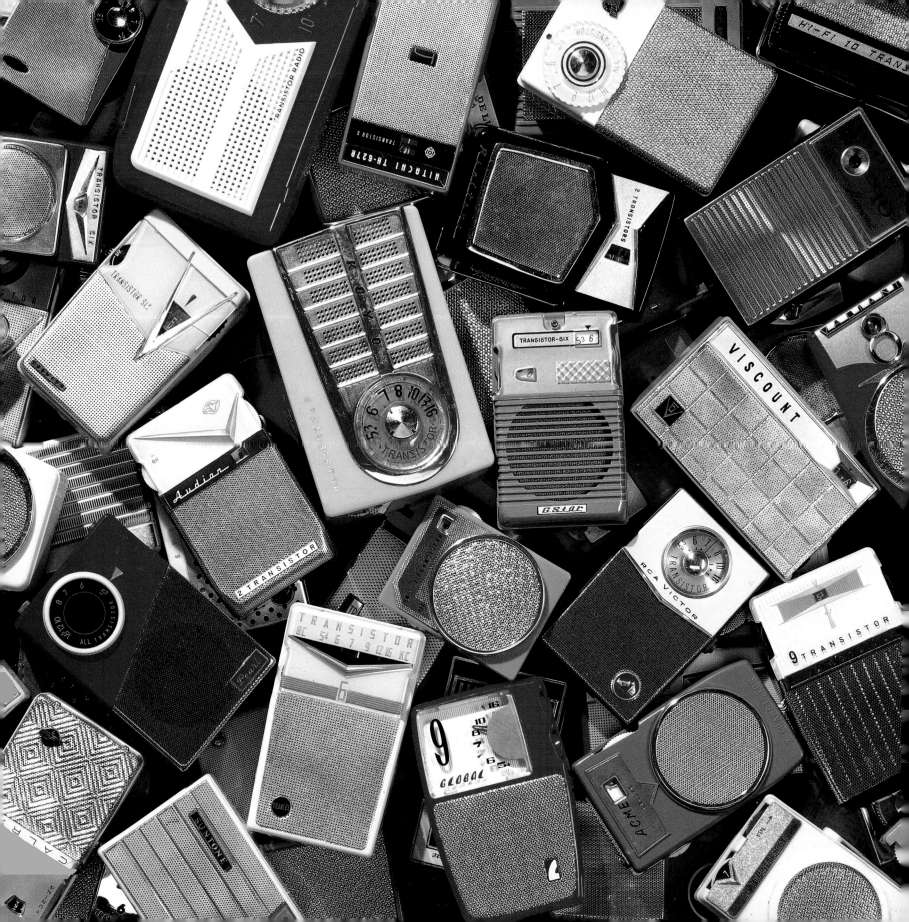